IMAGES
of America

SOUTH CAROLINA'S
LOWCOUNTRY

IMAGES
of America

SOUTH CAROLINA'S
LOWCOUNTRY

Anthony Chibbaro

ARCADIA
PUBLISHING

Published by Arcadia Publishing
Charleston, South Carolina

Printed in the United States of America

For all general information contact Arcadia Publishing at:
Telephone 843-853-2070
Fax 843-853-0044
E-mail sales@arcadiapublishing.com
For customer service and orders:
Toll-Free 1-888-313-2665

Visit us on the Internet at www.arcadiapublishing.com

CONTENTS

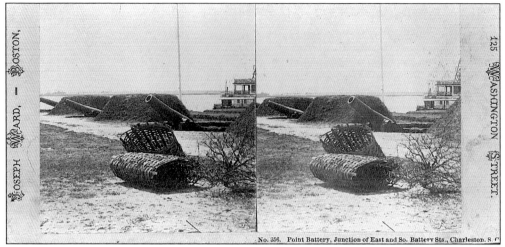

Stereoscopic view cards, also called stereoviews or stereographs, were extremely popular in the mid-to-late nineteenth century. In fact, next to portraiture, they were the prevailing photographic format of the day, with some families having hundreds of different views available in their parlors and family rooms. It was this extreme popularity that accounts for most of the surviving images from that time period. (Courtesy of Joseph Matheson.)

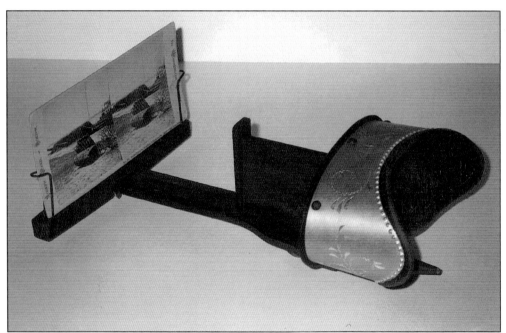

The cards were placed in a device called a stereoscope, or stereopticon. When viewed through the eyepiece of this device, the dual images merged into an inviting three-dimensional scene. In an age when there were no movies, televisions, radios, or hi-fi systems, it is no wonder that the stereoscopic view cards were so popular. (Courtesy of Kathryn Wood.)

INTRODUCTION

Billboard ads, newspapers, magazines, television, the computer, and now, the internet—we are bombarded with images. So many images, in fact, are thrust upon us on a daily basis that we have lost sight of the power that a single image can convey. The magic inherent in a seemingly simple photographic image, however, was not lost upon the pioneers of photography. Men such as George S. Cook, John Soule, George Barnard, and Mathew Brady instantly recognized the power of the new medium. These early photographers used a complex mixture of light, darkness, contrast, tone, and composition—much like an artist uses paint—to create powerful images that still speak to us today, more than 100 years later.

Entrepreneurs of the mid-1800s were quick to employ the new photographic technology to grab the attention of the public. The stereographic camera, invented prior to 1850 and in commercial production by 1854, was soon in wide use around the world. This camera had two separate lenses, and the glass negatives that resulted reflected this innovation. Each photographic subject was represented by a pair of images, one taken at an angle slightly offset from the other. These glass negatives were then used to manufacture the popular stereoview cards that some of us remember from grandmother's parlor and occasionally find today in antique shops and flea markets.

By use of another simple, but ingenious, device called a stereoscopic viewer (or stereoviewer for short), these flat, two-dimensional images were transformed into vibrant, three-dimensional tableaus. Grandmother, sitting quietly in her front parlor, could be figuratively transported thousands of miles into the midst of a beautiful landscape or a terrible disaster. Popular sterographic subjects of the late 1800s and early 1900s included views of Yosemite National Park, Niagara Falls, the Civil War, the San Francisco earthquake, the great Chicago fire, foreign cultures, U.S. presidents, and European royalty. Many a Victorian-era evening was spent enjoying the latest stereoviews with friends and family.

The South Carolina Lowcountry, comprised of the coastal areas surrounding and including the cities of Charleston, Beaufort, and Georgetown, proved to be a fitting subject for the stereographic photographers of the nineteenth century. The area's mix of beautiful scenery, exquisite architecture, Southern charm, and local flavor, coupled with a historic past, made it a favorite of many photographers of the day. Charleston photographers such as George S. Cook, George Barnard, Quinby & Co., F.A. Nowell, Osborn & Durbec, and S.T. Souder, as well as Beaufort's Sam Cooley, offered hundreds of different stereoviews of local subjects at their studios.

Unfortunately, the dawn of the twentieth century sounded the death knell for stereographic photography. Newer and more interesting diversions such as radio, moving pictures, and later, television, turned a once breathtaking innovation into yesterday's obsolete curiosity. Fortunately for us today, however, the powerful images grandmother enjoyed in her living room are now being rediscovered in her attic. Once again, enthusiastic viewers are being transported into exciting, three-dimensional worlds of beautiful scenery and important historical events—not of the present day, but of times past.

All photographs reproduced in this book have been taken from actual stereoviews published between 1860 and 1920, with the single exception of the photo on the bottom of page 6. The format of this book, however, precludes the publication of both images of the standard stereoview. Therefore, only one image will be reproduced herein. Although the interesting three-dimensional effect will be absent, the power of the image itself is still vibrantly alive and present.

In most cases the name of the publisher of each individual stereoview will appear in parentheses at the end of the caption. This name may or may not be the name of the actual photographer who exposed the glass negative, as copy negatives were commonly sold among photographers, which, in turn, resulted in identical stereoviews being published under different imprints. If there is no name at the end of the caption, the photograph is from a view published without a photographer's imprint. Occasionally, the photographer is known to history even when no imprint appears, and when this is the case, the photographer's name will appear as mentioned above.

ACKNOWLEDGMENTS

The author would like to acknowledge the help of several individuals who were instrumental in the work of this book: Mark Berry, Harlan Greene, Jeff Dygert, Len Ances, Joseph Matheson, John Steele, Marvin Housworth, Kathryn Wood, Jim Arnett, Bob Zeller, Cynthia Jenkins, Beth Bilderback, Steve Wise, Richard Hatcher, Jerry Harlowe, Skipper Keith, Jeffrey Kraus, David Spahr, Sharon Bennett, Bonnie Williams, the staff of the South Caroliniana Library, and the staff of the South Carolina Room at the Charleston County Public Library. Some contributed ideas, some provided inspiration, some helped with important research, and some loaned stereoviews for reproduction. All help was greatly appreciated.

The author would like to give special thanks to Harlan Greene at the Charleston County Library, for his assistance with research and his review of the manuscript; to Mark Berry at Arcadia Publishing, for his helpful advice; and to his wife and son, for being patient and understanding during the writing and publication of this book.

One

WAR COMES TO THE LOWCOUNTRY

SECESSION HALL AND THE CIRCULAR CONGREGATIONAL CHURCH, MEETING STREET, c. 1861. The building in the center of the view above was the home of the South Carolina Institute, an early mechanical and agricultural society headquartered in downtown Charleston. In December of 1860 and partly in response to Abraham Lincoln being elected president, the State of South Carolina voted to secede from the Union. The Ordinance of Secession, the document which put the Palmetto State on a collision course with the North and paved the way for the onset of the Civil War, was signed in the Institute's hall. The building then became popularly known as Secession Hall. This photo was probably taken in late 1860, just after the signing of the Ordinance, or in 1861, as all the buildings pictured were virtually destroyed in the Great Fire of the latter year. The Circular Church appears on the left. (Fred VonSanten.)

GORGE WALL AND SALLY PORT, FORT SUMTER, CHARLESTON HARBOR, APRIL 1861. Taken in the first few days after the opening battle of the Civil War, this panoramic photograph is a composite of four separate photos which have been pieced together. It is thought to be the work of George S. Cook or Osborn & Durbec. A close look at the right side of the photo will reveal pockmarks on the facade, where Confederate shells peppered the Union-held fort.

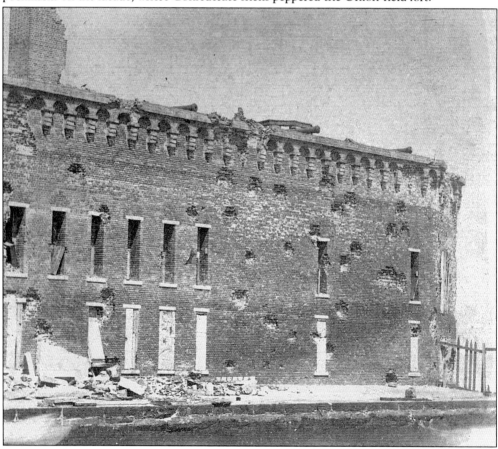

RIGHT QUARTER OF GORGE WALL AND RIGHT GORGE ANGLE, FORT SUMTER, APRIL 1861. This photo presents a better view of the effect of the Confederate cannon on Sumter's walls. The shells that did this damage originated from gunners located at Cummings Point on Morris Island. One of these shell marks is from the famous shot fired by radical secessionist Edmund Ruffin of Virginia, which awoke Union Captain Abner Doubleday, asleep in Sumter's officers' quarters at the time.

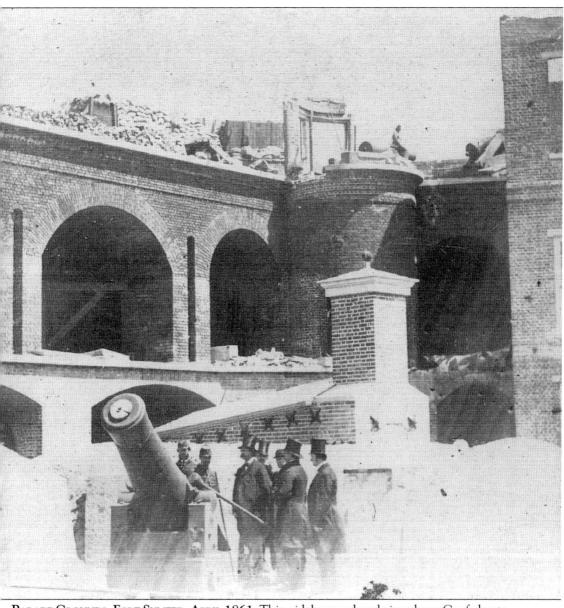

Parade Grounds, Fort Sumter, April 1861. This widely reproduced view shows Confederate dignitaries inspecting a Columbiad cannon that was poised to fire on downtown Charleston. Major Robert Anderson, commander of the beleaguered Union forces inside Sumter, had ordered that this cannon, along with several others, be positioned like a mortar and be made ready to fire on the city itself. Fortunately, he never gave the final order to fire. The tall gentleman in the top hat, standing closest to the cannon, has long been thought to be Wade Hampton, a man who was to become a successful Confederate general and, later, a popular governor of South Carolina. However, he is not mentioned as having visited the fort in any of the many newspaper reports of the day. Contemporary media accounts do place then-governor Francis Pickens at the fort on April 14, along with Colonel F.J. Moses Jr., J.L. Dearing, Chancellor Carroll, and Judges Glover and Wardlaw. Note the hot shot furnace standing immediately behind the group.

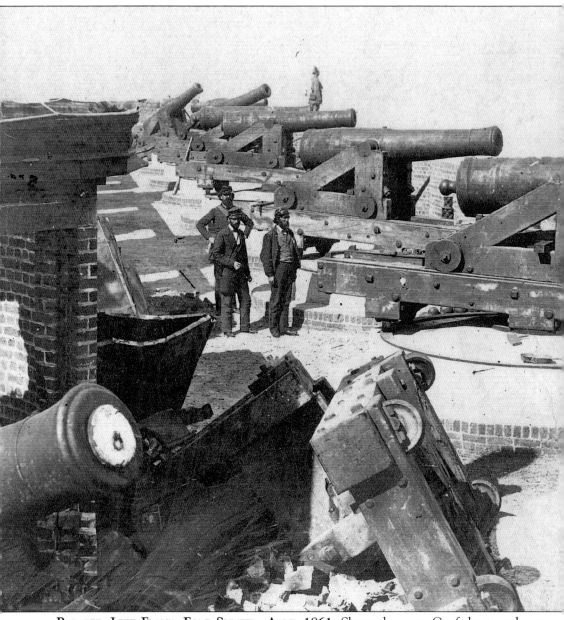

PARAPET, LEFT FLANK, FORT SUMTER, APRIL 1861. Shown here are Confederate ordnance officers in the process of inspecting the damage done to Fort Sumter by the Floating Battery, a floating gun platform placed in Charleston Harbor by Confederate forces. Officials of the young Confederacy were quick to survey their newly occupied position in order to make it defensible. The Union forces inside Sumter had been exposed to a bombardment that lasted 34 hours and consisted of over 3,000 rounds. Amazingly, there were no Union fatalities. However, two Yankee soldiers were killed during the flag-lowering ceremonies after the surrender. A 100-gun salute had been negotiated by Union commander Anderson, during which there was a mishap that caused a pile of powder cartridges to explode. The explosion killed one gunner on the spot and wounded a second, who died the following day. The dismounted gun in the foreground may have been caused by excessive recoil upon firing or by damage from incoming shells.

FORT SUMTER, PARADE GROUNDS, APRIL 1861. This photo presents another view of the damage done by the secessionist cannonade to the interior of Fort Sumter. In the foreground appears the fort's main flagpole, which was hit several times by incoming shells and was finally broken in half.

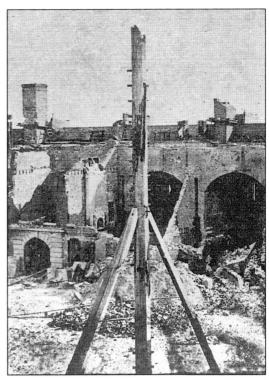

RAMPART OF FORT MOULTRIE, SULLIVAN'S ISLAND, APRIL 1861. There was much activity in Fort Moultrie also in the days after the Union surrender of Fort Sumter. The Confederate forces concentrated on shoring up their defenses. Sandbags are evident in the foreground and in the distance. They were utilized in conjunction with palmetto logs to create traverses for added protection against enemy fire.

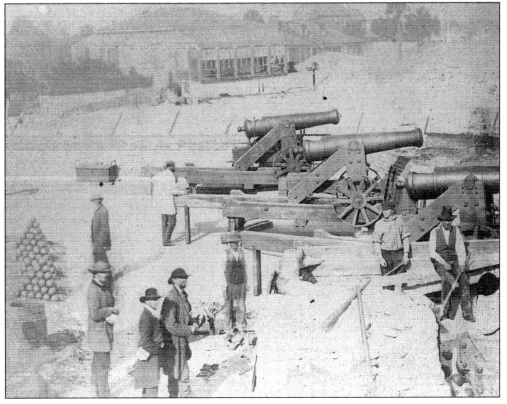

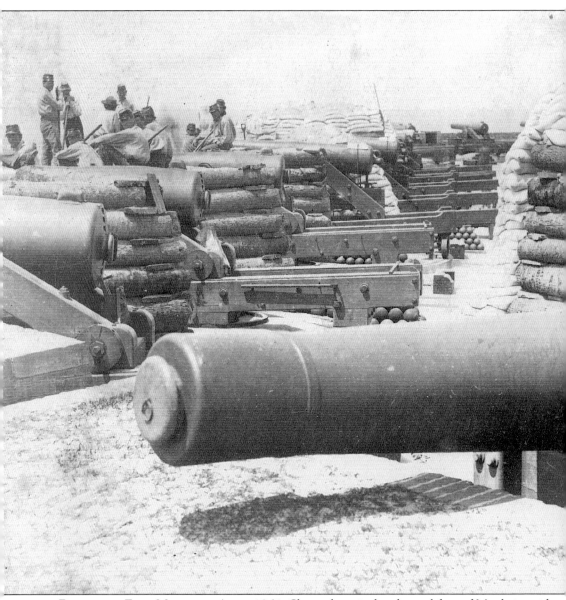

PARAPET OF FORT MOULTRIE, APRIL 1861. Shown here is the channel face of Moultrie, with guns at the ready. Now silent, they had only recently been active in the bombardment of Union-held Fort Sumter. The Confederate soldiers in the background seem to be relaxing in the spring sunshine. This was not the first time that Moultrie had seen men and guns come together in time of war. The proud fort had played a large part in defending Charleston against British warships during the Revolutionary War, when it was called Fort Sullivan, and during the War of 1812. In peacetime, the fort had also hosted such notables as Edgar Allan Poe, William Tecumseh Sherman, Braxton Bragg, and Abner Doubleday, all of whom were stationed there at one time or another prior to the Civil War. Seminole Indian leader Osceola was a reluctant resident of the fort, being imprisoned there in the 1830s. He died during his confinement and was buried right outside the Sally Port entrance. (S.T. Souder.)

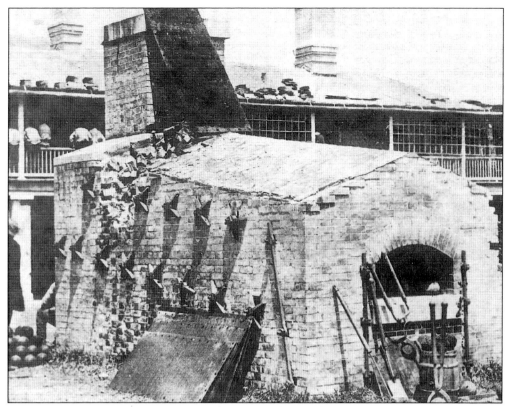

INTERIOR OF FORT MOULTRIE, 1861. This view, taken early in the war and probably shortly after the surrender of Fort Sumter by Union forces, shows the hot shot furnace inside Fort Moultrie. This furnace was used to heat Confederate ordnance that was fired at Sumter, in hopes that it would cause a fire or set off an explosion in a powder magazine. The damage to the furnace indicates that Union forces inside Fort Sumter were able to answer the Confederate bombardment with shells of their own. (Courtesy of Len Ances.)

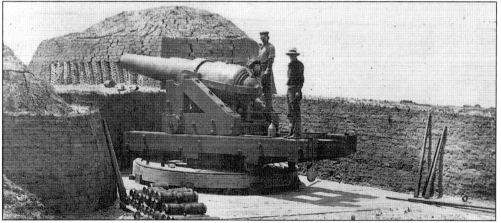

UNIDENTIFIED BATTERY, SULLIVAN'S ISLAND, 1865. The area near Fort Moultrie was strengthened with several supporting batteries throughout the course of the war. Shown here is a 9-inch Brooke seacoast rifle, one of the most powerful guns that was available to the Confederacy. Note the stack of ordnance in the foreground. (George S. Cook.)

15

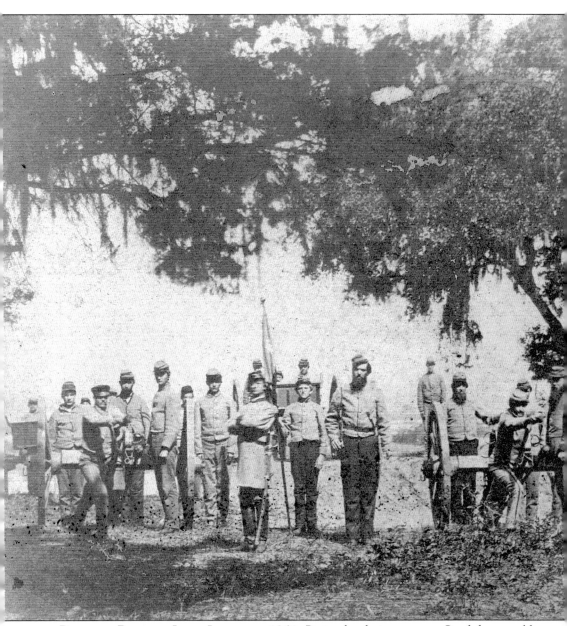

PALMETTO BATTERY, JAMES ISLAND, C. 1861. Posing by their cannons, Confederate soldiers, assumed by some to be members of the Palmetto Light Infantry, demonstrate their readiness and resolve to defend the fledgling Confederacy. Other researchers, however, have identified the unit as Company I of the Charleston Light Infantry. Regardless of the identity of the militia unit depicted in the photograph, it is a fact that hundreds of Charleston families contributed sons to such units, which, in turn, saw action in many battles in the Charleston area during the war. The topography of the land in the photograph suggests that it may have been taken near Fort Pemberton, on the western side of James Island. If so, that would be the Stono River in the background. But some researchers hold that the setting could be the Confederate fortifications on Cole's Island, before the works were abandoned in 1862. (George S. Cook, photographer; courtesy of John Steele.)

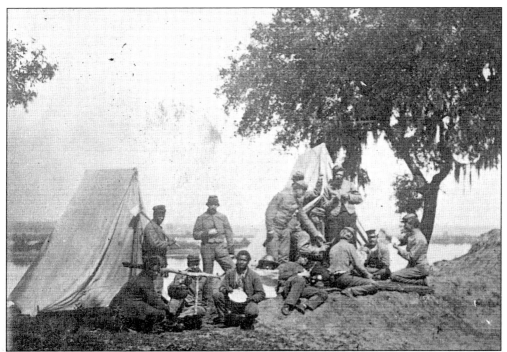

CONFEDERATE PICKET CAMP, JAMES ISLAND, C. 1861. The same soldiers as in the previous photograph are shown relaxing near their tents. Confederate forces in encampments like this were spread across James Island to protect Charleston from invasion by Union troops from the south. Also note the African-American men at the left of the photo, probably slaves brought into the camp to perform certain duties. The Stono River can again be seen in the background. (George S. Cook.)

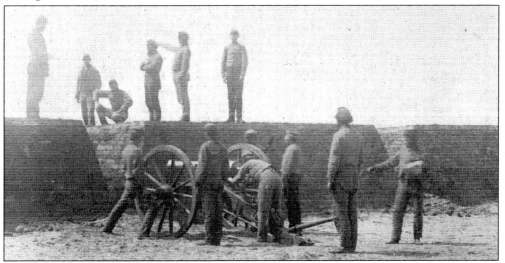

CONFEDERATE FIELD ARTILLERY, JAMES ISLAND, C. 1861. In this view, members of the same company practice sighting a piece of field artillery. Note the young soldier standing on the earthwork facing the camera; he seems to be the same soldier holding the colors in the photo on the facing page. Again note the presence of an African American at the far right, who also appears in the photo above. (George S. Cook)

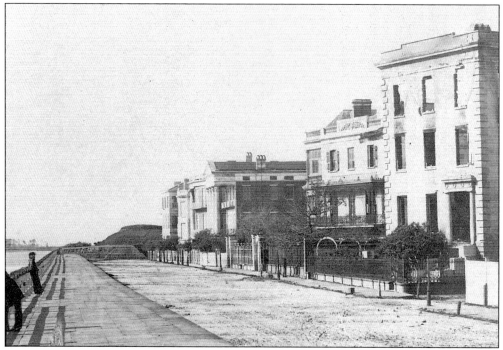

EAST BATTERY, C. 1865. Areas of the city of Charleston itself were not immune to being commandeered for the war effort. Battery Ramsay, consisting of a large bombproof and associated entrenchments, can be seen in the distance at the southern end of East Battery, where White Point Gardens is now located. (E. & H.T. Anthony.)

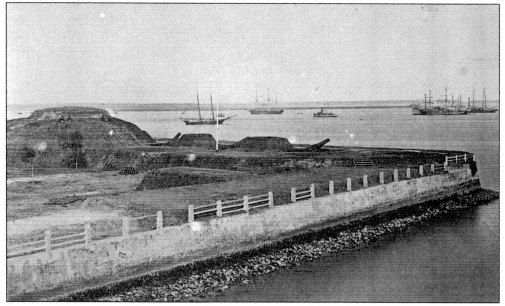

BATTERY RAMSAY OR WHITE POINT BATTERY, 1865. Shown here is a closer view of the entrenchments and bombproofs placed at the southwestern corner of the Battery. This photo was taken from the bathhouse, a portion of which is visible in the next photo. Note the excavations made to provide the soil and sand for the large bombproof. (George S. Cook.)

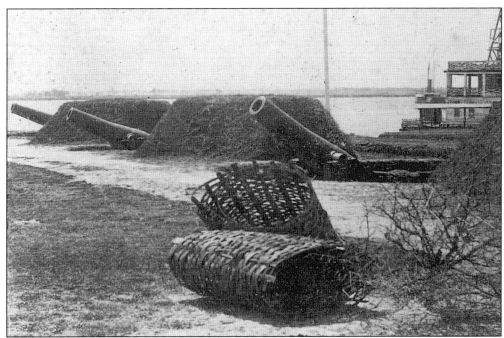

BATTERY RAMSAY OR WHITE POINT BATTERY, 1865. A different view of the guns placed at the southeastern point of the peninsula is presented by this photograph. The caption on the reverse states that the gun at the far left had been salvaged from the wreck of the Union ironclad *Keokuk*. Also note a portion of the bathhouse at the far right, complete with an observation tower on its roof. (E. & H.T. Anthony, publisher; courtesy of Joseph Matheson.)

FORT JOHNSON, JAMES ISLAND, 1865. Confederate forces were able to occupy Fort Johnson, along with Moultrie and Sumter, for almost the entire duration of the war. Even with the aid of heavy bombardment by gun emplacements on Morris Island and the ironclads of the blockading fleet, the Union was never able to take these three forts by force of arms. It was only when Confederate soldiers retreated in February of 1865 that the Union flag flew again over Fort Sumter, which can be seen in the distance. (John P. Soule, photographer; courtesy of Len Ances.)

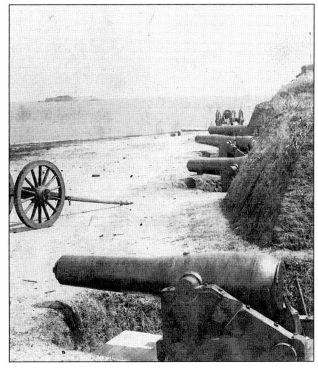

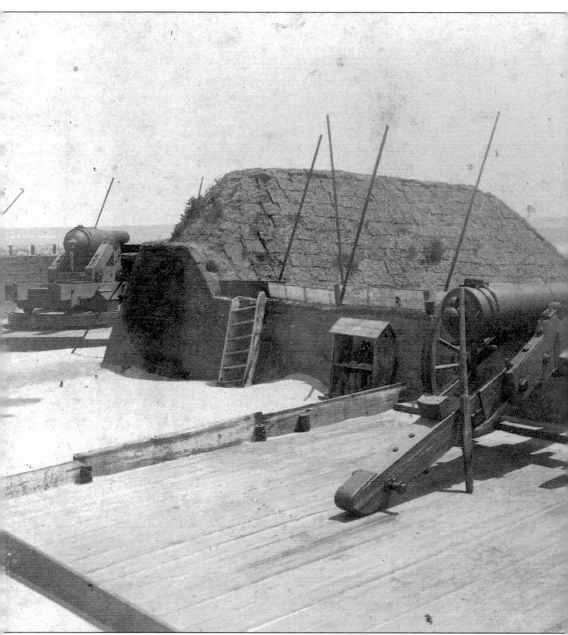

BATTERY MARSHALL, SULLIVAN'S ISLAND, 1865. Defensive positions were also created on the eastern end of Sullivan's Island. This installation guarded the inlet between Sullivan's Island and the Isle of Palms. The famous Confederate submarine, the C.S.S. *Hunley*, was sometimes anchored at Battery Marshall. In February of 1864, she weighed anchor from her berth near the battery and made her successful, but ill-fated, attack on the U.S.S. *Housatonic*. It is interesting to note that the birth of stereographic photography almost coincided with the onset of the Civil War. Many of the most prominent photographers of the nineteenth century perfected their techniques during the war. Fortunately, their photos were able to capture the essence of the Civil War as it was and are still able to convey that across the years to us today. (E. & H.T. Anthony.)

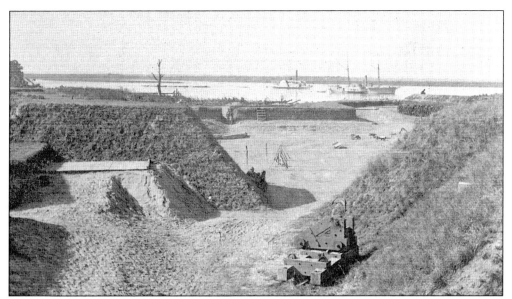

UNIDENTIFIED EARTHWORKS, C. 1861–1865. Earthworks like these were a common sight in the Lowcountry during the war. There were at least 60 earthwork batteries built by Confederate forces in the Charleston area to help in the effort of defending the city against Union attack. The location depicted in this particular view is unidentified at the present time. Note the two sidewheelers in the distance.

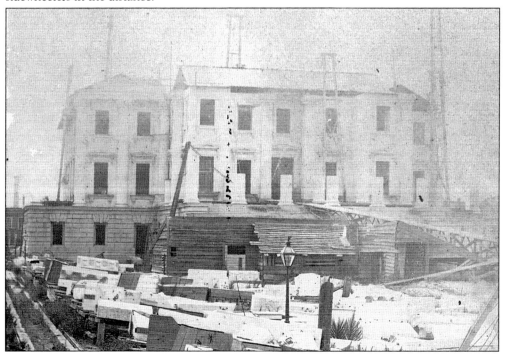

CUSTOM HOUSE, EAST BAY STREET, C. 1861. With all the preparations for war going on elsewhere, construction of the U.S. Custom House was suspended. Designed by Ammi Burnham Young and begun in 1853, the building was not finished until 1879, long after the end of the war.

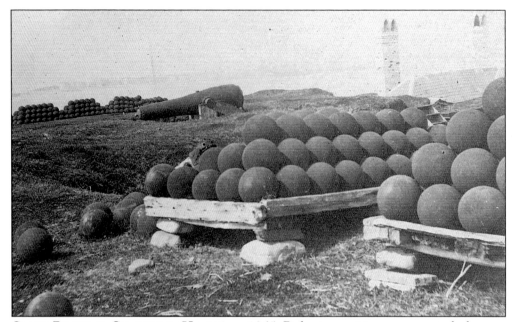

CASTLE PINCKNEY, CHARLESTON HARBOR, C. 1865. Defensive positions were created wherever possible to prepare for the inevitable Union attack. Here, at Castle Pinckney, on the southern tip of Shute's Folly Island, cannon and shot awaited any Northern assault that made it past the main harbor defenses. (George S. Cook.)

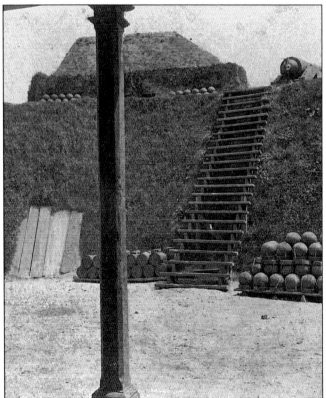

INTERIOR OF CASTLE PINCKNEY, C. 1865. Castle Pinckney saw double duty during the war. Besides the defensive duties made apparent in this photo, the installation also served for a period of time as a prison for captured Union soldiers. (E. & H.T. Anthony.)

Two

THE GATES OF HELL

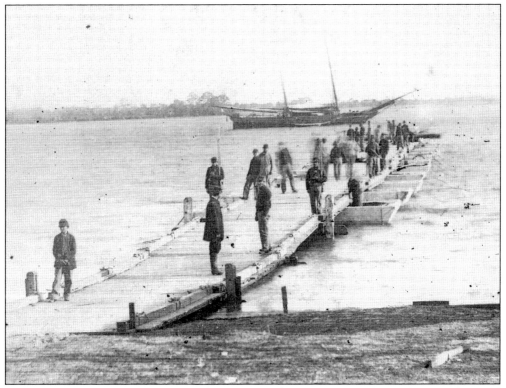

UNION PONTOON WHARF, NEAR BEAUFORT, 1862. The Union responded to the capitulation of Fort Sumter by sending a large fleet to Port Royal Sound, capturing Hilton Head, Beaufort, and Port Royal very early in the war. Commandeering many existing buildings and erecting other facilities there, the Union utilized the Beaufort area as their headquarters for the armies of the Department of the South. All the forces in the Lowcountry, including both ground troops and the blockading fleet, were supplied from these facilities. In this photo a temporary pontoon wharf is being constructed in Port Royal Sound in March of 1862, probably for the offloading of troops and supplies. Temporary structures such as this were soon followed with more permanent structures. (Taylor & Huntington.)

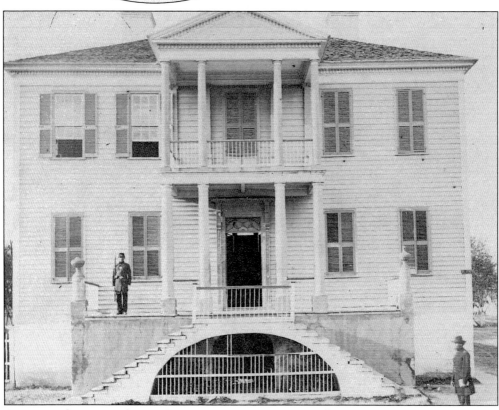

GENERAL STEVENS AND STAFF, BEAUFORT, MARCH, 1862. General Isaac I. Stevens was the commander of several regiments of Union soldiers quartered on Port Royal Island in 1862. He and his forces participated in an attempt to capture Charleston by invading James Island in June of that year. The attempt was repulsed by Confederate forces in hard fighting at Secessionville. Later that same year, Stevens was killed at the battle of Chantilly, Virginia. (Taylor & Huntington, publisher; courtesy of Jeff Dygert.)

ADJUTANT GENERAL'S OFFICE, BEAUFORT, C. 1862. Union officers were quick to commandeer buildings in Beaufort to use for wartime purposes. Here the John Mark Verdier House, built in 1790 and from whose portico Lafayette spoke in 1825, has been taken over by Union troops and is being used by the adjutant general. The building is now the home of a museum and the Historic Beaufort Foundation. (Sam Cooley, photographer; courtesy of Marvin Housworth.)

GENERAL SAXTON AND FAMILY, BEAUFORT, FEBRUARY 1865. In 1862, Brigadier General Rufus Saxton took over command of Union forces in Beaufort from General Stevens, who had been transferred to Virginia. Saxton held strong abolitionist beliefs and was also placed in charge of raising African-American troops in South Carolina. Comprised almost entirely of former slaves, the 1st South Carolina Volunteer Infantry was taken into Federal service outside Beaufort on January 1, 1863. (E. Hubbard, photographer; courtesy of Marvin Housworth.)

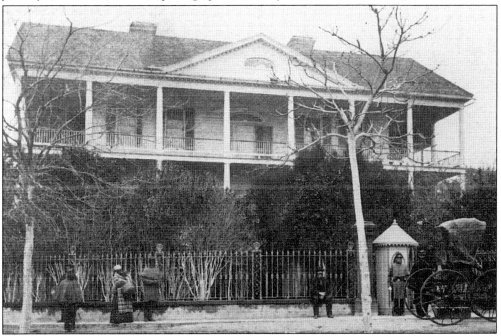

GENERAL SAXTON'S RESIDENCE, CORNER OF BAY AND NEWCASTLE STREETS, BEAUFORT, FEBRUARY 1864. Saxton took up residence in a home erected c. 1820 for George M. Stoney, using it as his headquarters for the duration of the war. The building was later turned into the Sea Island Hotel and was in business as such for some 80 years. (Sam Cooley, photographer; courtesy of the South Caroliniana Library.)

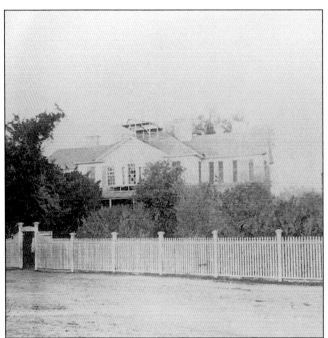

SIGNAL & TELEGRAPH OFFICE, BEAUFORT, C. 1863. The Union needed some way of keeping the lines of communication open between all their personnel, so they set up a complex series of signal stations and telegraph lines. This photo shows a Beaufort residence that is being utilized as a telegraph and signal office. Note the signal platform built on its roof. (Sam Cooley, photographer; courtesy of the South Caroliniana Library.)

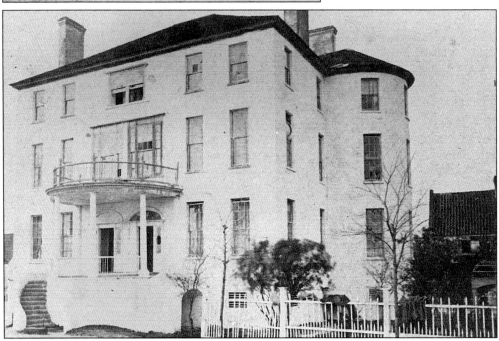

CONTRABAND HOSPITAL, BEAUFORT, C. 1863. The old "Barnwell Castle" was taken over for use as a hospital for contrabands, former slaves who had either been abandoned when the Union invaded the area or had run away from their plantations. When it became widely known that Union troops had occupied Beaufort, many African Americans sought protection behind the Federal lines. The historic building, in which Lafayette had been entertained during his 1825 visit, was destroyed by fire in 1881. (Sam Cooley, photographer; courtesy of the South Caroliniana Library.)

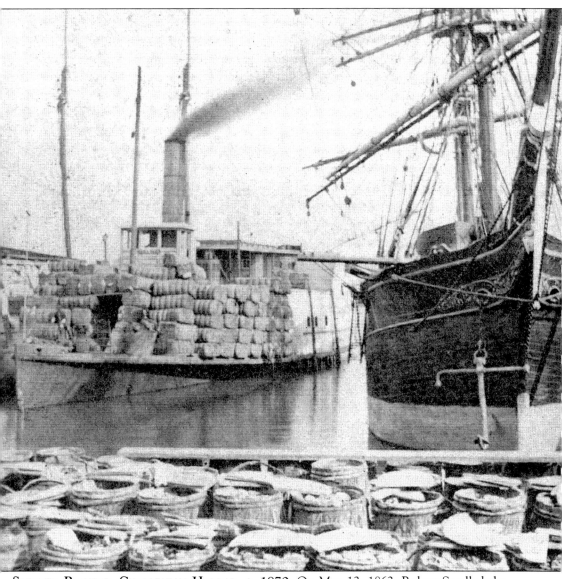

STEAMER PLANTER, CHARLESTON HARBOR, C. 1870. On May 12, 1862, Robert Smalls led a small group of fellow slaves aboard his master's steamer, the *Planter*. Smalls was the regular pilot of this boat and was very experienced in navigating around the numerous shoals and sandbars in Charleston Harbor. He maneuvered the *Planter* to another dock, there picking up his family and the families of his ragtag crew. He then made his way out into the harbor, safely passing the watch at both Fort Moultrie and Fort Sumter, and promptly surrendered to the Union blockading fleet. In this way, Smalls not only gained freedom for himself, his family, and his friends, but also proved that an African American could be relied upon to take bold steps on his own behalf. The commander of the Union blockade recognized Smalls's usefulness and allowed him to command the *Planter* for the duration of the war as a member of the blockading fleet. Smalls also passed on valuable knowledge about Confederate troop movements, allowing Union officers to plan an attack on James Island. Shown in this post-war view, the *Planter* has since become reacquainted with her more staid pre-war duties of hauling rice and cotton. She was reportedly wrecked near Cape Romain in 1876. (American Views, Standard Series.)

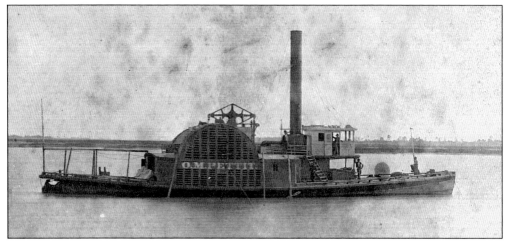

STEAMER *O.M. PETTIT*, PORT ROYAL HARBOR, c. 1865. Steamers like the *O.M. Pettit*, pictured above, were pressed into service by Federal forces to bring men and war materiel to and from the Beaufort area. Thousands of soldiers and countless boxes of supplies were ferried South during the Union buildup. The ships were also used to transport soldiers and supplies to the front lines. (Wilson & Havens, photographer; courtesy of Marvin Housworth.)

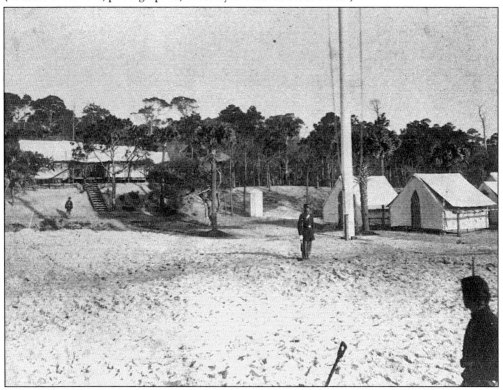

GENERAL GILLMORE'S QUARTERS, FOLLY ISLAND, c. 1863. Brigadier General Quincy A. Gillmore had been sent to the Union's Department of the South to replace General David A. Hunter, whose inadequacies were blamed for the Yankee defeat at Secessionville in 1862. Gillmore wasted no time in devising a new offensive strategy to capture the city of Charleston. (Sam Cooley, photographer; courtesy of the South Caroliniana Library.)

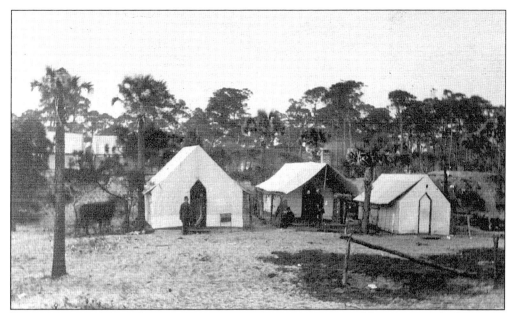

PROVOST MARSHALL'S HEADQUARTERS, FOLLY ISLAND, C. 1863. Union troops had been in possession of Folly Island since April of 1863. The original plan of capturing Charleston by route of James Island had been disastrous and Gillmore did not want his command to suffer the same mistake. He therefore composed a new plan that involved landing thousands of soldiers on Folly and Morris Islands. These two barrier islands had been previously ignored by Union forces, but became the focus of intense activity in 1863. (Sam Cooley, photographer; courtesy of Marvin Housworth.)

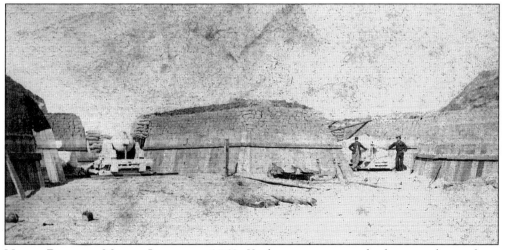

NAVAL BATTERY, MORRIS ISLAND, C. 1863. Yankee troops stormed ashore on the southern end of Morris Island on July 10, 1863. Gillmore's scheme was to take the whole of the island and then use siege guns installed on its northern end to reduce Fort Sumter. With Sumter disabled, Gillmore thought, Union ships could easily enter the harbor and capture Charleston. However, Confederate stronghold Battery Wagner, located on the northern half of the island, was a formidable obstacle to his plan. As Union forces moved up the coast toward Wagner, they built fortifications along the way. This one was located on the southern half of Morris Island. (E. & H.T. Anthony.)

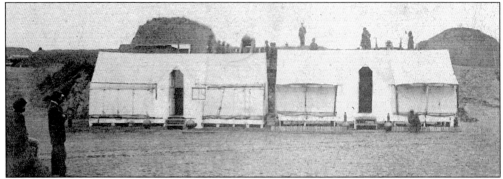

OFFICERS' QUARTERS, INTERIOR OF FORT STRONG, MORRIS ISLAND, C. 1865. On July 18, 1863, Union forces, spearheaded by the 54th Massachusetts Infantry, attempted a ground assault on Confederate Battery Wagner. The 54th Massachusetts was made up of African-American enlisted men and was led by a white officer, Colonel Robert Gould Shaw. The assault was repelled in gory, hand-to-hand combat after a battle of several hours. Colonel Shaw was killed, as were most of his men. The intense fighting led one participant to label Morris Island as the "Gate of Hell." (This battle formed the plot of the movie *Glory*, filmed in nearby Savannah in 1989.) In September, however, Confederate forces were forced to abandon their position. Shown in this photo are the Union officers' quarters after the North took over the evacuated battery and renamed it Fort Strong, in honor of Union General George C. Strong. (E. & H.T. Anthony.)

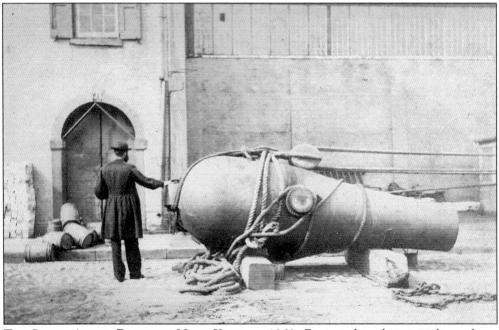

THE SWAMP ANGEL, BROOKLYN NAVY YARD, C. 1863. Frustrated in their initial assault on Battery Wagner, Union forces on Morris Island began to eye the city of Charleston itself. Although the city was over 4 miles away, the Yankees set up a battery in the marsh on the western portion of the island. A very large gun, nicknamed the Swamp Angel, was brought in to bombard the city. The photo here purportedly depicts the gun before it was transported to Charleston. The caption is in error, however, as the original Swamp Angel was a 200-pound Parrott rifle; the gun in the photo is not. (E. & H.T. Anthony.)

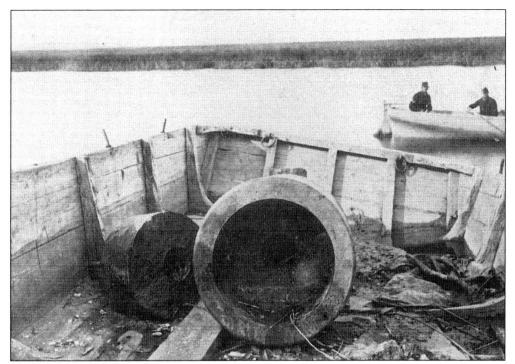

REMNANTS OF THE SWAMP ANGEL, NEAR MORRIS ISLAND, C. 1865. On the night of August 22, 1863, the Swamp Angel lobbed its first incendiary shell into downtown Charleston. Confederate General P.G.T. Beauregard was incensed that Union forces were shelling the defenseless citizenry, but there was little he could do about it. The shelling did not go on for long, however, as the large gun burst after the 36th round. Shown above are two of the three pieces that were left after the explosion. (E. & H.T. Anthony, publisher; courtesy of the South Caroliniana Library.)

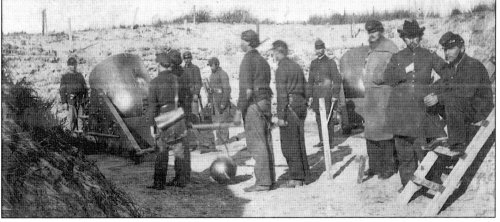

MORTAR BATTERY, INTERIOR OF FORT PUTNAM, C. 1863. After commandeering the evacuated Battery Gregg, abandoned at the same time as Battery Wagner, Union forces were quick to take advantage of its proximity to Fort Sumter. Large mortars like this one were used to loft shot high into the air, which then fell into the interior of Sumter. The detachment shown here is preparing to load the mortar for firing. Note that the four men in the foreground had to carry the 200-pound shell. (John C. Taylor.)

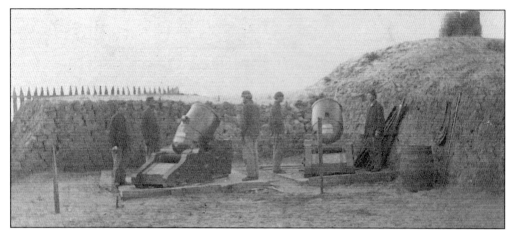

UNION MORTAR BATTERY, FORT CHATFIELD, MORRIS ISLAND, C. 1863. It was from installations like this that the Union forces bombarded Fort Sumter unrelentingly during 1863 and 1864. General Gillmore's plan to use Morris Island as a foothold to reduce Fort Sumter and then take Charleston itself was successful in part. By the end of 1864, Fort Sumter had been reduced to little more than a pile of rubble. But Yankee soldiers were never able to take Fort Sumter by direct assault, and were thwarted in their plan to capture Charleston until the Confederate forces evacuated shortly before the end of the war. (E. & H.T. Anthony.)

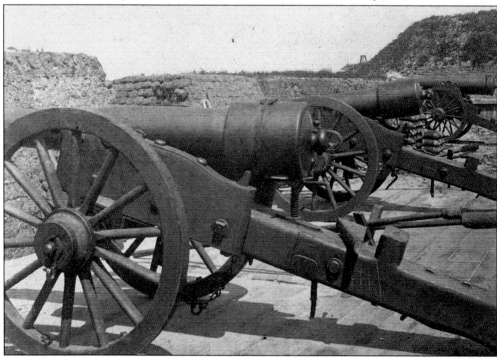

INTERIOR OF FORT PUTNAM, MORRIS ISLAND, C. 1865. Battery Gregg, located on Cummings Point at the northern tip of Morris Island, was evacuated by Confederate forces in September of 1863. The battery was taken over by Union forces and was renamed Fort Putnam, in honor of Colonel Haldiman S. Putnam, who died in the attempt to capture Battery Wagner. Fort Putnam was one of a trio of forts from which the Yankees pounded Fort Sumter for a period of 13 months in 1863 and 1864. (E. & H.T. Anthony.)

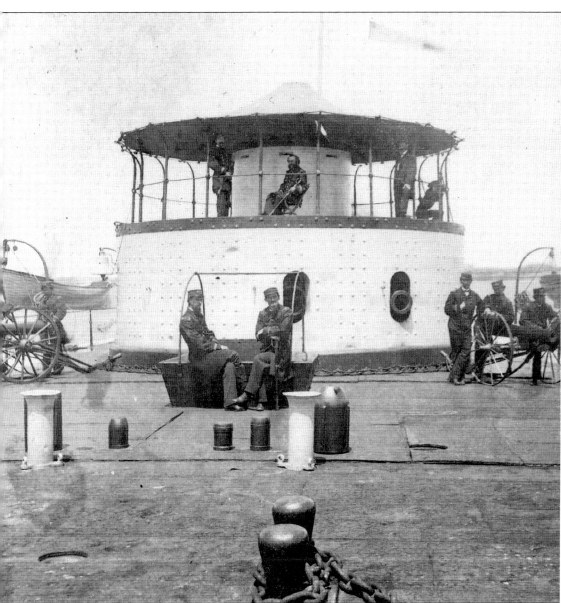

DECK AND TURRET OF MONITOR CATSKILL, CHARLESTON HARBOR, C. 1865. Fort Sumter received heavy fire not only from the Union fortifications on Morris Island, but also from the blockading fleet. Beginning in the spring of 1863, the Union fleet could call upon the services of several of its new class of ironclad warships. Based out of Port Royal during the war were the monitors *Weehawken, Passaic, Keokuk, Nahant, Nantucket, Patapsco, Montauk,* and *Catskill.* Sporting two large guns inside their heavily armored turrets, each ship could fire at Sumter and Moultrie and feel almost impregnable to return fire. But despite its seeming edge, the Union fleet was never able to blast its way past the main harbor defenses. In this view, the staff of the *Catskill* poses for the photographer. The commanding officer of the ship, Lieutenant Commander Edward Barrett, is seated atop the turret, while the remainder of his staff strike poses elsewhere on the deck. Note the two small cannon at each side of the turret and the four shells that appear in the foreground.

PARAPET, FORT SUMTER, 1863. On September 8, 1863, Charleston photographer George S. Cook went to Fort Sumter to take some photographs. He had been asked by the Confederate government to take photos that could be used by the army to make decisions about Sumter's future. While there, Cook noticed that there was an engagement between three Union vessels and Fort Moultrie. He was able to get two exposures of a pair of Union ironclads and the Union flagship *New Ironsides* in the act of firing upon Moultrie. These were the first photographs of record known to have been taken under actual battle conditions, and one is included here despite its poor quality. The Union ships apparently noticed some movement at Sumter, perhaps thinking Cook was preparing to fire a cannon, and sent a few shells its way. In this historically important photo, the two ironclads appear left of center. Fort Moultrie is off camera to the left, and the parapet of Fort Sumter is in the immediate foreground. The *New Ironsides* does not appear in this shot due to excessive fading of the original print. (George S. Cook.)

UNIDENTIFIED PASSAIC-CLASS MONITOR, C. 1863. Despite their seeming invincibility, the Union ironclads were not invulnerable. In this photo, a Yankee sailor poses by the turret of a battle-scarred monitor. Even though direct hits like these did not penetrate the heavy armor plating, they were sometimes lethal to the gunners inside because their force would cause bolts and other pieces of metal to become flying projectiles inside the turret. The slow and ungainly monitors were also vulnerable to mines and attack by torpedo boats. (John C. Taylor.)

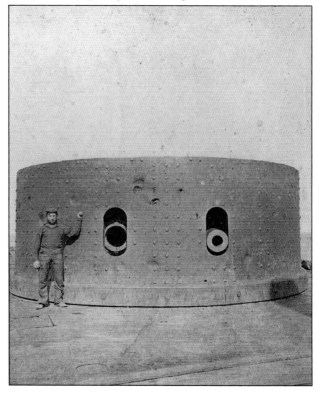

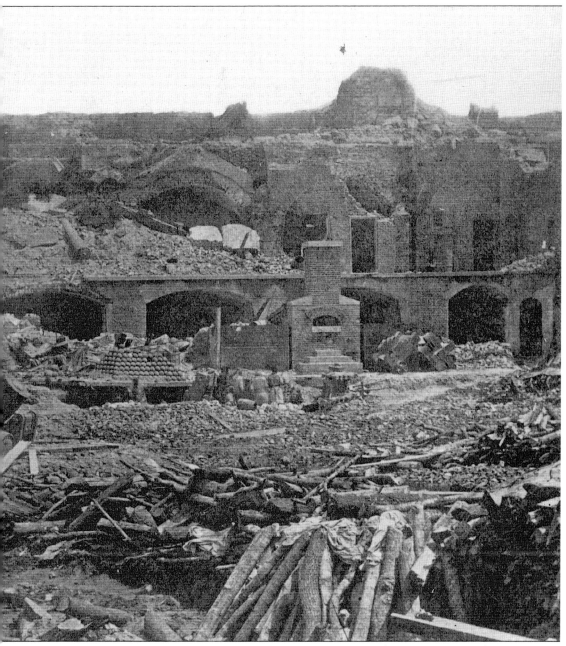

FORMER PARADE GROUNDS, INTERIOR OF FORT SUMTER, 1864. The damage to Sumter from the almost constant Union bombardment is apparent in this view taken during one of Cook's visits. The 13 months of shelling had taken its toll on the once-proud fort. From August 17, 1863, to September 18, 1864, the Union artillerists fired approximately 43,000 rounds at Fort Sumter, completely demolishing the gorge wall, the right face, and the right flank of the fort. The Confederate garrison suffered a little over 300 casualties—63 dead and almost 250 wounded. Miraculously, the hot shot furnace remains almost untouched in the middle of what was once the parade grounds. Compare this photo to the one taken in 1861 on page 11. (George S. Cook.)

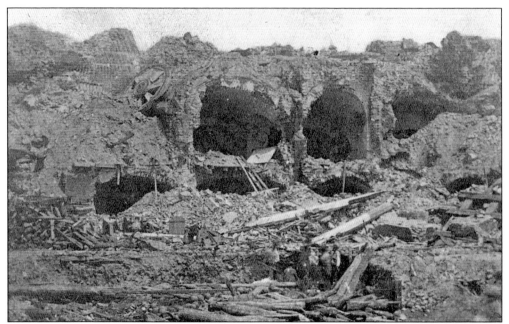

FORMER PARADE GROUNDS, INTERIOR OF FORT SUMTER, 1864. Here is another view of the interior of Sumter taken by Cook, this one showing the almost total destruction of its masonry walls. Note the presence of the work detail in the middle of the photo, busy filling sandbags. Also, right behind them are two remnants of the fort's original flagpole. (George S. Cook.)

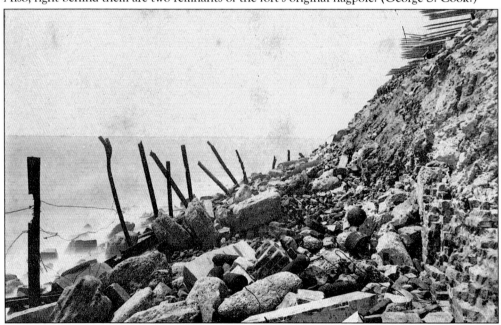

RIGHT FLANK, FORT SUMTER, 1865. This portion of Sumter's facade took the brunt of the fire from the Union fleet. The ironclads would line up and take turns firing on this face of Sumter, succeeding in reducing it to a mound of rubble. The abatis visible at the top right and the iron bars strung with wire at the shoreline were erected to repel an amphibious landing by Yankee forces.

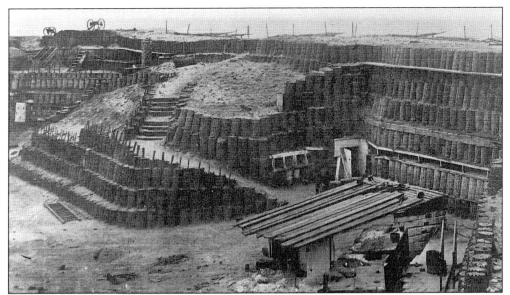

INTERIOR OF FORT SUMTER, 1865. The caption on this view, taken by George S. Cook, stresses how the walls were strengthened by use of wicker baskets called gabions. The gabions were used to construct the large bombproof right behind the gorge wall, which had been destroyed by Union guns on Morris Island. (George S. Cook.)

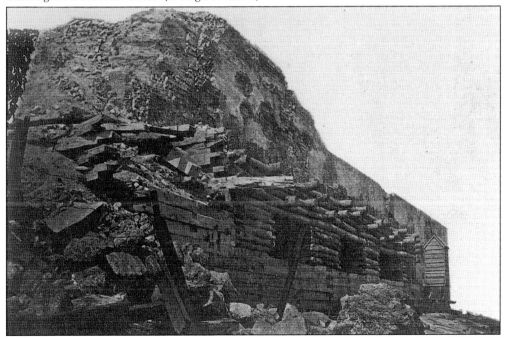

SALIENT ANGLE AND LEFT FACE, FORT SUMTER, 1865. The damage to Sumter's facade here was less severe than the eastern and southern faces. Using palmetto logs, the Confederate garrison constructed a three-gun battery to help in defending the inner harbor against Union intrusion by providing a degree of crossfire with neighboring Fort Moultrie. Federal fire from the ironclads in the outer harbor and the batteries on Morris Island were unable to reach it. (George S. Cook.)

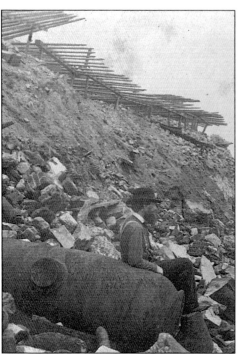

RIGHT FLANK, FORT SUMTER, 1865.
Boston photographer John P. Soule came to Charleston at the war's end to document the destruction for his Northern customers. While in the area, he exposed about 40 negatives of Fort Sumter, Fort Moultrie, and other important installations. Here Soule, or an assistant, poses on one of Sumter's guns that had been toppled from the parapet during one of the Union bombardments. (John P. Soule.)

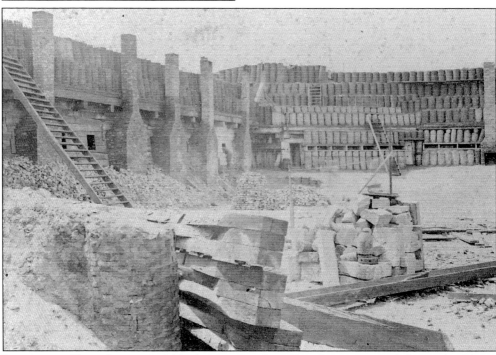

INTERIOR OF FORT SUMTER, 1865. As response from Fort Sumter quieted down, the Union gunners turned their attention to Fort Moultrie and the city of Charleston. This allowed the garrison at Sumter time for makeshift repairs. Large wicker gabions were stacked upon each other and filled with sand and debris to create a semblance of order and protection. This photo, probably taken after the war ended, shows the officers' quarters. (E. & H.T. Anthony.)

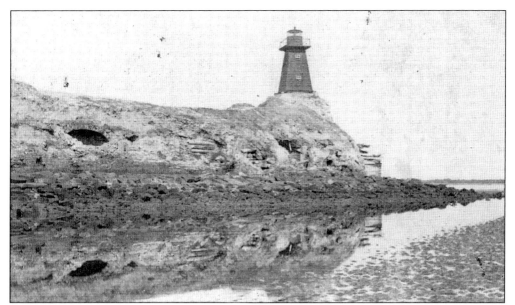

RIGHT FACE OF FORT SUMTER, C. 1868. A brand-new channel light, added to Sumter's salient angle after the war, stands in stark contrast to her shattered eastern facade. Tens of thousands of rounds of shot and shell fell on this side of Sumter during 1863 and 1864.

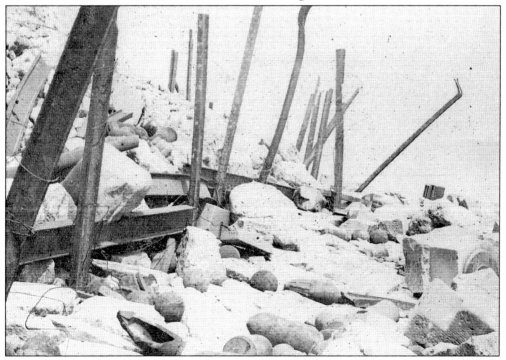

REMAINS OF THE GORGE WALL, FORT SUMTER, 1865. The gorge wall, Sumter's weakest facade and the one facing Morris Island, fared the worst during the Union bombardments. Amid the mass of rubble can be seen exploded and unexploded shot and shell. Also note the iron bars strung with wire, which the Confederate garrison placed to guard against an amphibious assault. (E. & H.T. Anthony.)

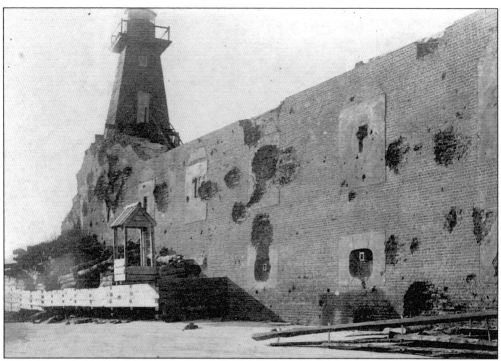

SALIENT ANGLE AND LEFT FACE, FORT SUMTER, C. 1870. Sumter's northwestern face stands relatively untouched compared to its other facades, as it was protected from the bulk of Union fire due to its northwestern orientation. Note the remnants of the three-gun battery, which was in the process of being dismantled. (Quinby & Co.)

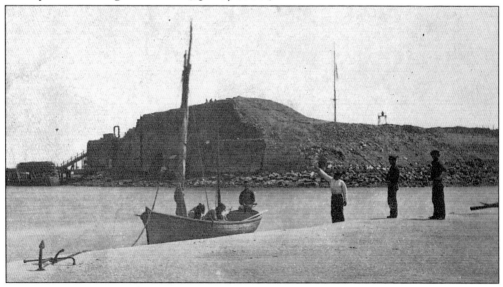

LEFT FLANK AND LEFT GORGE ANGLE, FORT SUMTER, C. 1865. The contrast between the exposed and protected areas of Sumter is apparent in this photo. Sumter's southern facade, exposed to fire from Union emplacements on Cummings Point and Morris Island, is a mere pile of rubble, while the western facade, visible directly behind the boat, was protected from Yankee shot and shell.

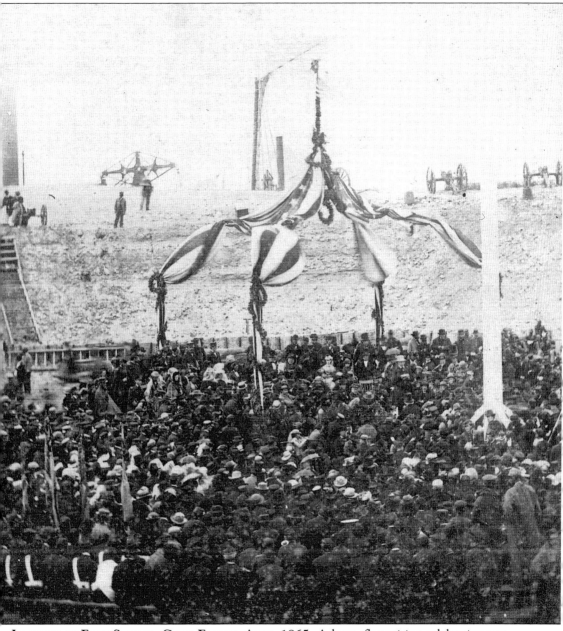

INTERIOR OF FORT SUMTER, GOOD FRIDAY, APRIL 1865. A large, flag-raising celebration was held inside Fort Sumter on April 14, 1865, four years to the day of the initial Union surrender of Sumter to Confederate forces. The former commander of the fort, Robert Anderson, now a Union general, was on hand to raise the very same flag that he had lowered in 1861. Robert Smalls was also in attendance, arriving at Sumter on his boat, the *Planter*. In this photo, Reverend Henry Ward Beecher, a staunch abolitionist and brother of Harriet Beecher Stowe, addresses the assembled dignitaries. President Abraham Lincoln had planned to attend, but decided not to travel to Charleston, sending in his stead John G. Nicolay, his personal secretary. Later that same day, the President was shot in Ford's Theater in Washington. He died the following day. (E. & H.T. Anthony.)

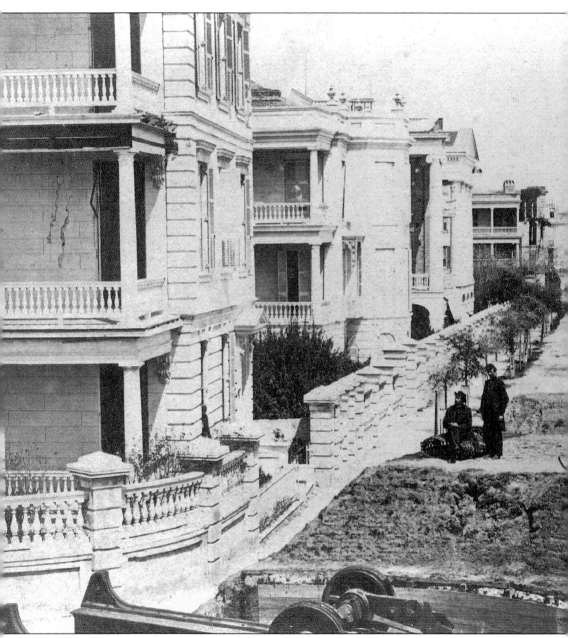

EAST BATTERY, 1865. Sometime during the war, Confederate forces defending Charleston placed a large Blakely gun weighing over 30 tons in service at White Point Battery. Unable to take the heavy gun with them during the February 1865 evacuation, they chose to destroy it rather than allowing it to fall into enemy hands. The explosion sent the huge gun and its carriage high into the air. A large piece of the carriage fell onto the roof of the de Saussure House at 1 East Battery. A smaller piece of the gun's barrel flew through the roof of the Roper House at 9 East Battery and came to rest upon the rafters. During repairs made later to this house, it was decided best to leave the fragment alone, and it remains in the attic to this day. Pictured here in front of the de Saussure House is the remainder of the gun carriage, along with a pair of Union soldiers. (E. & H.T. Anthony.)

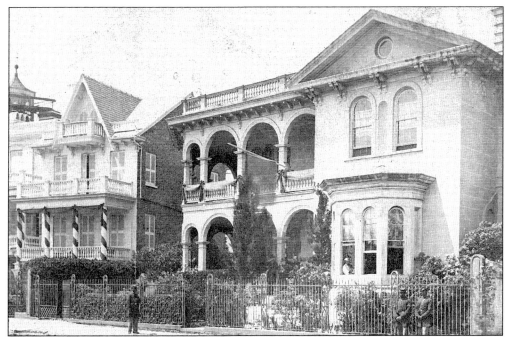

26 SOUTH BATTERY, CHARLESTON, 1865. After the Confederate evacuation in February of 1865, Union forces were quick to set up a headquarters in Charleston. The caption on the back of this view identifies the house in this photo as General Hatch's headquarters. It has long been thought that Hatch had stayed at 27 King Street. Perhaps this home was used as his offices, while he kept his residence around the corner on King. Note the Union soldiers on guard duty outside the iron fence. The presence of the black bunting on the house next door suggests that this photo was taken shortly after President Lincoln was assassinated. (E. & H.T. Anthony.)

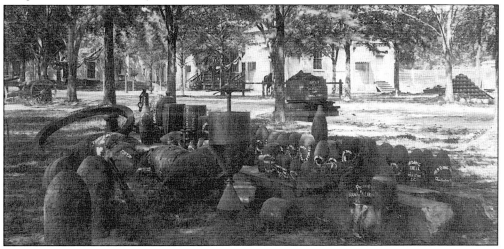

GROUP OF RELICS, CHARLESTON ARSENAL, 1865. A now mute collection of Confederate ordnance was placed on display at the Arsenal by occupying Union forces. The many different types of shot, shell, and torpedo were identified in white lettering for the interested viewer. Among the relics was the shattered breech of the 600-pound Blakely gun that once stood in White Point Battery. See the facing page for a picture of the carriage upon which this sat. (E. & H.T. Anthony.)

43

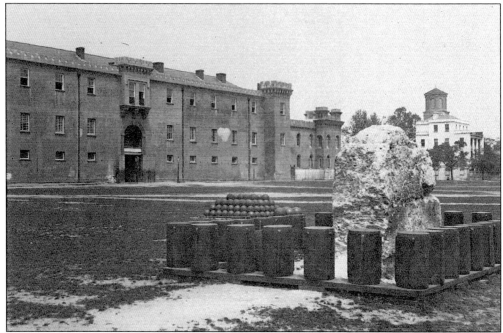

THE OLD CITADEL BUILDING AND THE CITADEL GREEN, 1865. The original home of the South Carolina Military Institute shows little activity at the war's end. The Citadel had contributed many soldiers to the Confederate cause during the war effort, however. In the foreground is the "hornworks," a portion of the original siege wall of colonial Charleston, along with a host of Confederate ordnance. (E. & H.T. Anthony.)

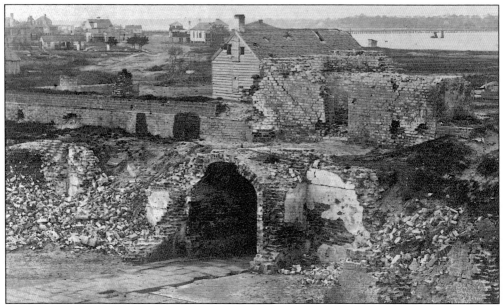

INTERIOR OF FORT MOULTRIE, 1865. Fort Moultrie also sustained considerable damage during the war. The interior, shown here shortly after the war ended, stands as a testament to the effects of Union shell. Note the presence of Moultrieville in the distance. (John P. Soule, photographer; courtesy of Joseph Matheson.)

Three

THE HOLY CITY
IN RUINS

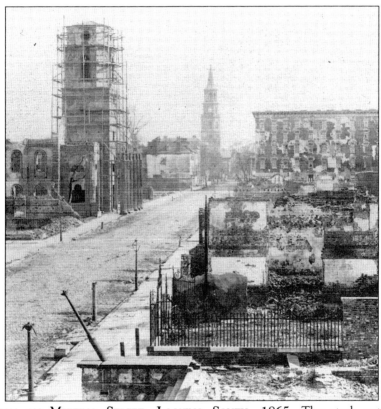

DESTRUCTION ON MEETING STREET, LOOKING SOUTH, 1865. The stark nature of the devastation on Meeting Street is fully apparent in this view. Most of the damage seen was caused not by Union shells, but by the Great Fire, which swept through the city on December 11, 1861. Thought to have started in the woodworking shop of William P. Russell at the foot of Hasell Street, the fire quickly spread to Market Street, then State, Meeting, Broad, and Tradd Streets. When the conflagration had finally run its course, five churches, 500 residences, and many commercial buildings were left in ruins. The fire actually did more damage to the city than all the subsequent Union bombardments. Note the Mills House and Saint Michael's Church in the distance, two buildings that were miraculously spared by the fire. Also note the scaffolded ruins of the Circular Church appearing in the middle foreground. (E. & H.T. Anthony.)

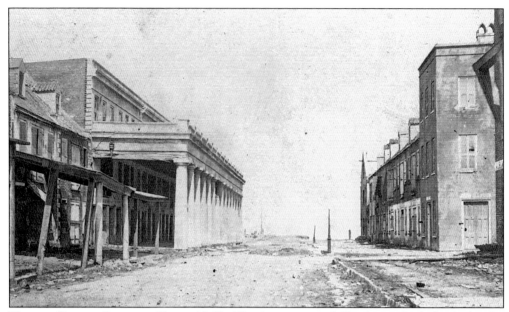

VENDUE RANGE, LOOKING EAST, 1865. The lower part of Charleston had the look of a ghost town in early 1865 when this photo was taken. The city suffered heavily during the war, not only from the bombardments and the fire, but also from the lack of commercial activity. (E. & H.T. Anthony.)

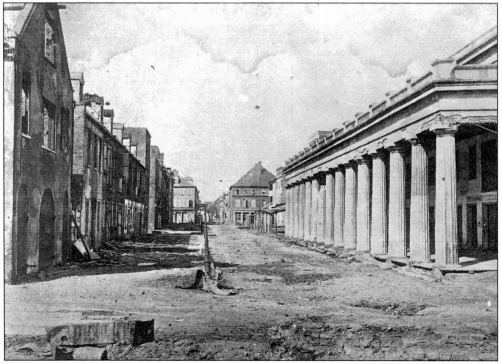

VENDUE RANGE, LOOKING WEST, 1865. This view was taken at approximately the same time as the preceding one. The deserted streets and dilapidated buildings stand as a mute testament to the war's devastation. Note the unexploded shell at the lower left. (George S. Cook.)

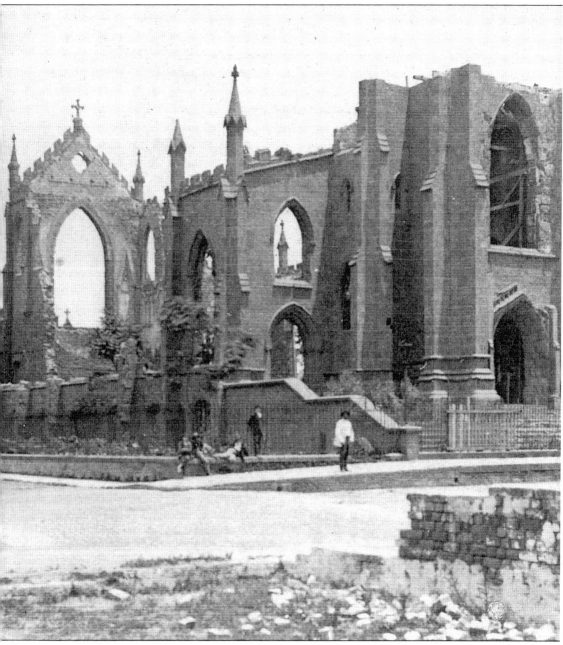

RUINS OF THE CHURCH OF SAINT JOHN THE BAPTIST AND SAINT FINBAR, BROAD STREET, c. 1867. Known simply as Saint Finbar's, the Roman Catholic church on Broad Street was also a casualty of the Great Fire of 1861. Finished in 1854, only seven years prior to the fire, the structure in the view above was designed by architect P.C. Keely of Brooklyn. The building was made of Connecticut sandstone at great cost and had a spire over 200 feet tall. After the fire, it was learned that an oversight had allowed the insurance policy to lapse, resulting in an interval of over 50 years until the church was rebuilt. The present church on the site, started in 1890 and finished in 1907, was built from virtually identical plans. The new edifice was named the Cathedral of Saint John the Baptist. (F.A. Nowell.)

47

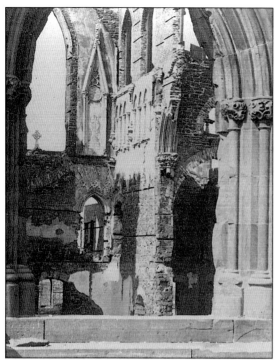

SIDE ENTRANCE, CHURCH OF SAINT JOHN THE BAPTIST AND SAINT FINBAR, BROAD STREET, C. 1867. The Great Fire destroyed everything at Saint Finbar's, including a 17,000-volume library, the adjoining rectory, and all the church vestments and sacred vessels. The congregation worshiped for a period of time at Hibernian Hall, and later at an interim church on Queen Street. (John P. Soule.)

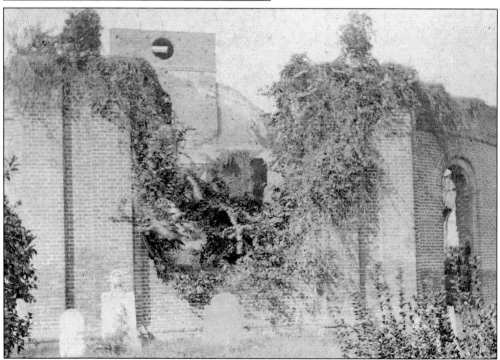

RUINS OF THE CIRCULAR CONGREGATIONAL CHURCH, MEETING STREET, C. 1870. The Circular Church was also in the path of the Great Fire. The ruins sat undisturbed for many years until they were knocked down by the 1886 earthquake. The same bricks were then used to rebuild the church, which was finished in 1892. (George N. Barnard.)

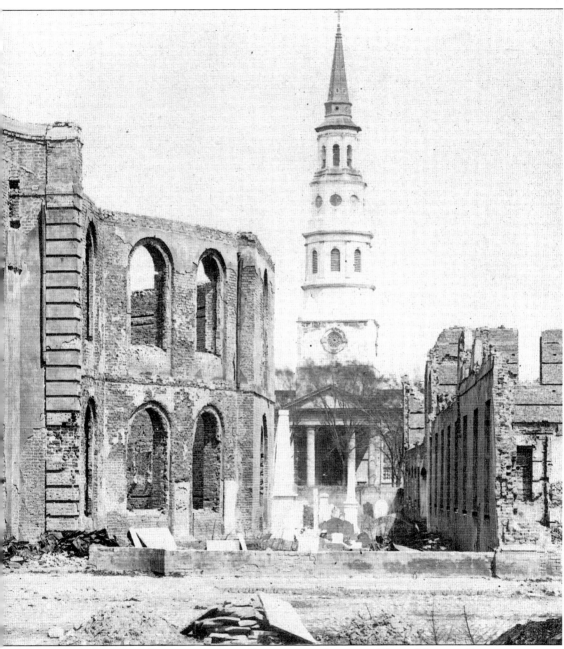

RUINS OF THE CIRCULAR CONGREGATIONAL CHURCH AND SECESSION HALL, MEETING STREET, 1865. Saint Philip's Episcopal Church stands in marked contrast to the ruins of the Circular Church and Secession Hall. Compare this view to the pre-fire photograph appearing on page 9. Saint Philip's, sandwiched between the two fire-ravaged buildings and one block behind them, had been spared by the Great Fire and also escaped the Union shelling without serious damage. The graveyard of the Circular Church, which is one of the oldest in the city and contains monuments dating from the 1700s, is visible to the right of the church itself, directly in front of Saint Philip's. The Great Fire was so intense that some of the gravestones in the churchyard were cracked by the extreme heat. (John P. Soule.)

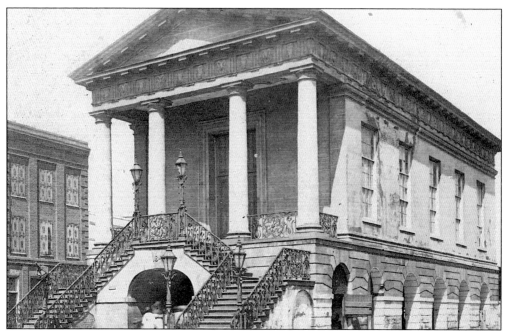

CORNER OF MARKET AND MEETING STREETS, 1865. The old Market Building made it through both the war and the Great Fire with no major damage. Designed by Edward Brickell White and erected in 1841, the Grecian-Doric structure has been the focus of commercial activity in Charleston ever since it was built. (E. & H.T. Anthony.)

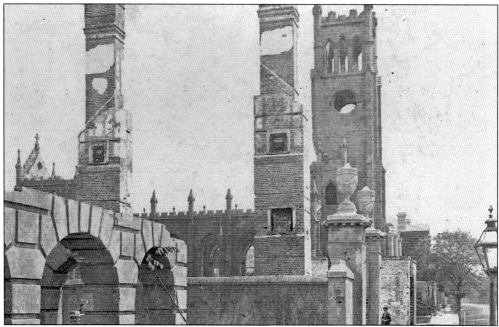

BROAD STREET, LOOKING EAST, 1865. Presented above is another view of the destruction on Broad Street. The bell tower of St. Finbar's Church can be seen in the middle foreground. The tower had either fallen or been torn down by the time that the photo on page 47 was taken. (Lawrence & Houseworth.)

VIEW OF THE VULCAN IRON WORKS, CUMBERLAND STREET, C. 1865. Business at the Vulcan Iron Works was certainly good in the early post-war period, if one is to judge by this photograph. Proprietor McLeish's building did not seem to suffer much from the war in its Cumberland Street location. (S.C. Northrup, photographer; courtesy of the South Caroliniana Library.)

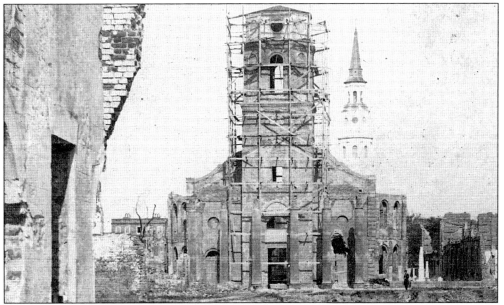

RUINS OF THE CIRCULAR CONGREGATIONAL CHURCH, MEETING STREET, 1865. The scaffolding around the spire of the Circular Church was erected during the war, or soon after the war, to strengthen the weakened structure and prevent it from falling. Even so, the earthquake of 1886 knocked it down and provided the impetus for rebuilding. (E. & H.T. Anthony.)

51

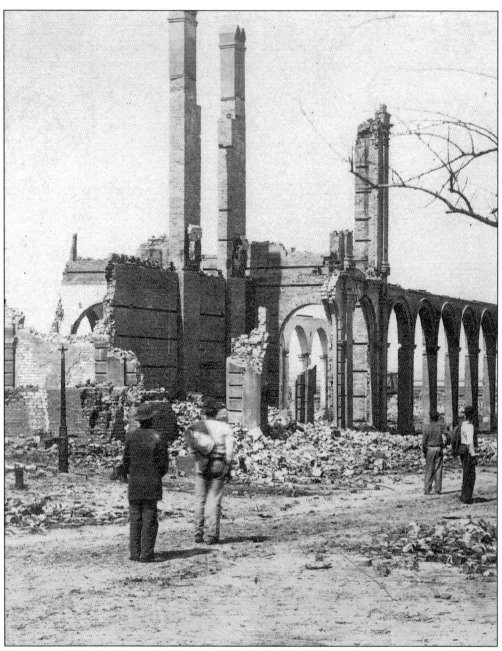

RUINS OF THE NORTH EASTERN DEPOT, 1865. As the Confederate forces evacuated in February of 1865, they were forced to leave behind many things, including gunpowder and other stores of material. The departing soldiers set fire to the vast cotton stores all over the city to prevent the precious commodity from falling into enemy hands. It is thought that a group of children took gunpowder from a depot storage shed to feed a fire deliberately set in a nearby warehouse, but in so doing created a trail of powder that allowed the fire to follow it back to the shed. The resulting explosion destroyed the depot and all nearby buildings, taking 150 lives. This was felt as a devastating loss for the residents of a city that had already seen so much death and destruction. (E. & H.T. Anthony.)

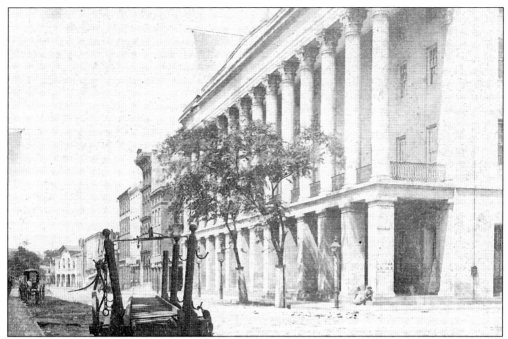

THE CHARLESTON HOTEL, MEETING STREET, 1865. Some buildings fared much better than others during the course of the conflict. The Charleston Hotel was able to stay in business for much of the war, remaining open until December of 1863, when it was forced to close due to danger from the shelling. While it was open, prominent guests included Confederate officers and members of Charleston's elite families. (E. & H.T. Anthony.)

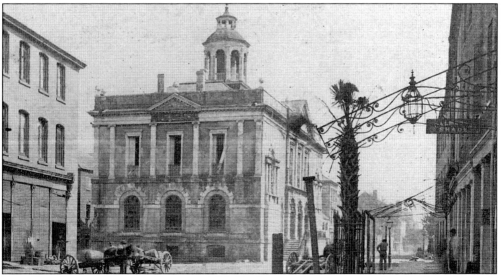

EAST BAY STREET, LOOKING SOUTH, 1865. Donkeys and wagons seemed to be the only mode of transportation still functioning at the war's end. This shot of East Bay Street shows the Exchange Building, which functioned as the post office at the time. The caption on the back of this stereoview ironically proclaimed the lone palmetto tree to be the only one still left in the city. Functioning as the state symbol, the palmetto tree had graced the uniforms of many of South Carolina's soldiers during the Civil War. (E. & H.T. Anthony.)

CLUB HOUSE, WASHINGTON RACE COURSE, 1865. The caption printed on some examples of this view states that Union prisoners were confined in the clubhouse on the race course during the war. Regardless of its use during the war, the structure seen above certainly shows the effects that the war had on buildings in Charleston. The race course later served as the site of the Interstate and West Indian Exposition and is now the area where Hampton Park is located. (John P. Soule.)

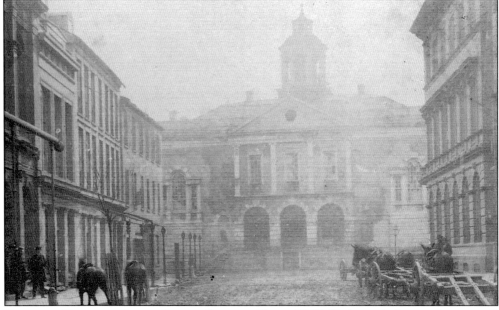

EXCHANGE BUILDING, BROAD STREET, LOOKING EAST, 1865. Broken windows and an overall haggardness greet the onlooker in this view taken from the middle of Broad Street. The Exchange Building, sitting in the middle of the photo at the foot of Broad, had seen war and its aftermath before, presiding over Charleston during both the Revolutionary War and the War of 1812. (W.E. James.)

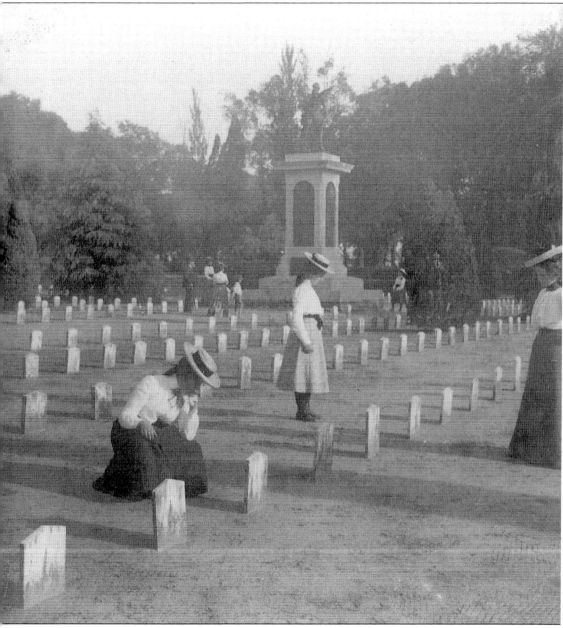

CONFEDERATE GRAVEYARD, MAGNOLIA CEMETERY, C. 1903. "The Fallen of the Mighty Conflict—Graves of Confederate Soldiers, Charleston, S.C.," reads the caption printed on this turn-of-the-century view. These ladies were not yet born when Charleston's youngest and brightest were asked to serve their country. Scores of Charlestonians died gallantly in the war, including many of the 800 that were buried here in South Carolina's only official Confederate cemetery. Most of those interred at Magnolia were killed in defense of the city of Charleston, but 84 were South Carolinians who lost their lives at the battle of Gettysburg. Five Confederate brigadier generals were also buried at Magnolia, along with the second crew of the C.S.S. *Hunley*, which included Horace L. Hunley, the submarine's designer. (Underwood & Underwood.)

GRAVES OF UNION PRISONERS AT THE RACE COURSE, 1865. War's most bitter harvest is forever the graves of the young. Union soldiers who died in captivity were put into temporary graves at the Washington Race Course, in an area known as the "Potter's Field." (John P. Soule.)

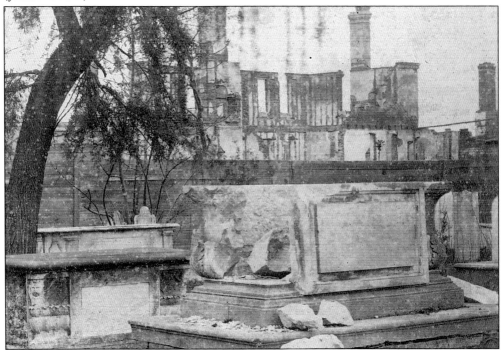

DAMAGE TO TOMBS IN THE CEMETERY OF THE CIRCULAR CHURCH, 1865. Even the deceased were subject to the war's woe. Shown above is the effect of the Union bombardments on one of the monuments in the graveyard of the Circular Congregational Church on Meeting Street. (E. & H.T. Anthony.)

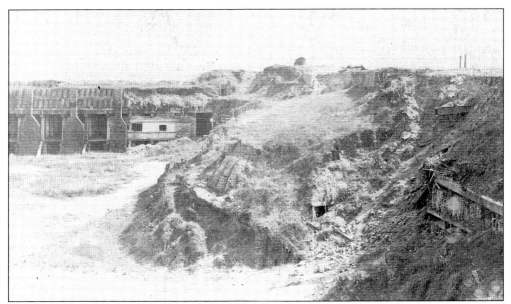

INTERIOR VIEW OF FORT SUMTER, C. 1870. In the late 1860s and early 1870s, the Federal government began to clean up Fort Sumter. Shown here is the same bombproof as shown in the photo on the top of page 37, but note that the wicker gabions are in the process of being removed. (Quinby & Co.)

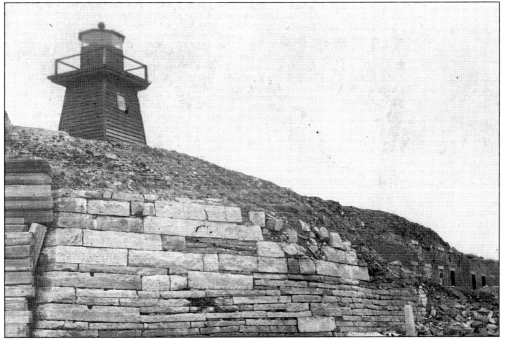

LEFT GORGE ANGLE, FORT SUMTER, C. 1875. During the war, the southwestern angle of Fort Sumter required strengthening, and the Confederate garrison used whatever materials were at hand. The stone that had made up the wharf extending from the sally port was taken up and used to strengthen the angle which had been weakened by the Federal bombardment. Also note the channel light built after the war on the fort's salient angle. (O. Pierre Havens.)

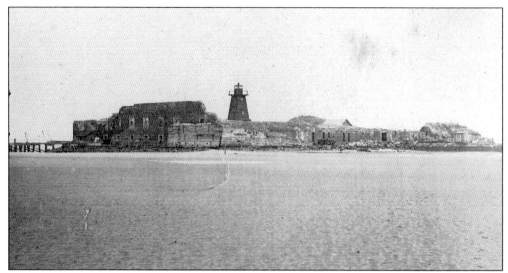

VIEW OF FORT SUMTER FROM THE SOUTHWEST, C. 1872. As the "recent unpleasantness" faded into the past, the appearance of Sumter's facades changed. Debris was removed from the base of the gorge wall, revealing the original sally port entrance again. Also note the outbuilding to the right and the wharf on the left.

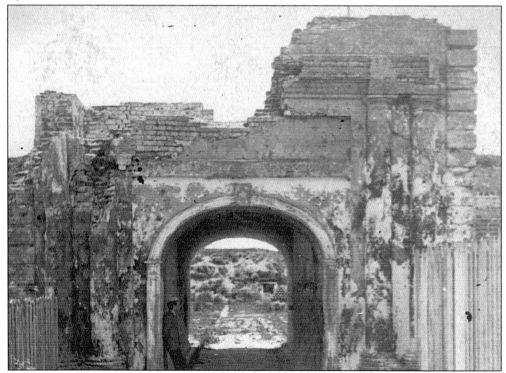

SALLY PORT, FORT MOULTRIE, C. 1868. The appearance of Fort Moultrie also changed after the end of the war, suffering somewhat under Mother Nature's glare. Three years of wind and rain, coupled with neglect, had weathered Moultrie's sally port. It would only be a few more years until the Federal government would repair the damage and mount new guns on Moultrie's parapet.

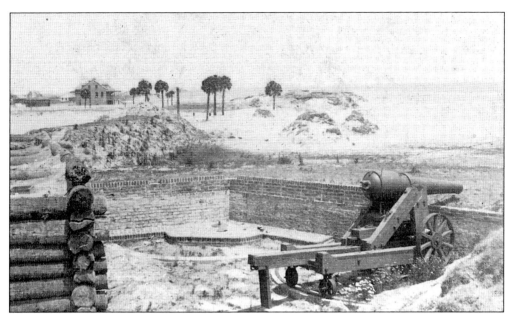

PARAPET OF FORT MOULTRIE, SULLIVAN'S ISLAND, C. 1868. The outer harbor is visible in the distance in this view. The Union blockading fleet would have been in sight there during the war. All is quiet now, no Union gunboats are in sight, and time has taken its toll on Moultrie. Note the remnants of Battery Rutledge just to the right of the palmetto trees, which now amounts to little more than a few simple sand dunes.

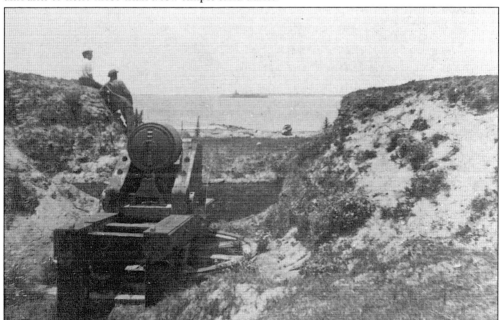

A VIEW OF FORT SUMTER FROM FORT MOULTRIE, C. 1868. In this photo taken from Moultrie's parapet, Fort Sumter can be seen in the distance, sitting in the middle of the harbor. The view must have been similar in 1861 when young Confederate soldiers, willing and eager to serve their newborn country, took aim and fired upon the Union-held bastion. Only now, Sumter's once proud form is but a shadow of its former self. (S.T. Souder.)

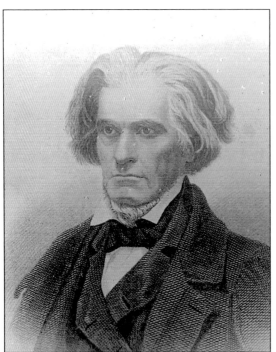

JOHN C. CALHOUN. Although not an actual photograph, this image of "The Great Nullifier" was reproduced from a stereoview. Calhoun's views on the subjects of states' rights, slavery, and North-South sectionalism were well known and paved the way for South Carolina's secession from the Union. During his long political career, Calhoun served in the U.S. House of Representatives and the U.S. Senate, and also as the secretary of state and vice president. He died in 1850, long before the actual start of the Civil War, but his ideas and rhetoric presaged it. It was providential that Calhoun did not live to see that his politics led to the virtual destruction of the South. (Keystone View Company.)

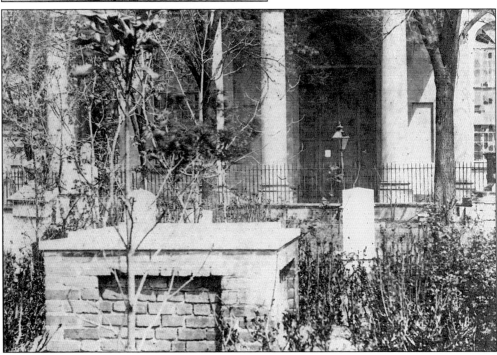

TOMB OF JOHN C. CALHOUN, SAINT PHILIP'S CHURCH GRAVEYARD, C. 1865. In reality, Calhoun's tomb was empty at the time this photo was taken. His body had been disinterred by the Confederates and secreted elsewhere in the graveyard during the war lest the Union capture Charleston and desecrate Calhoun's grave. His remains were later reburied in his original tomb. (John P. Soule.)

Four

CHARLESTON REBUILDS

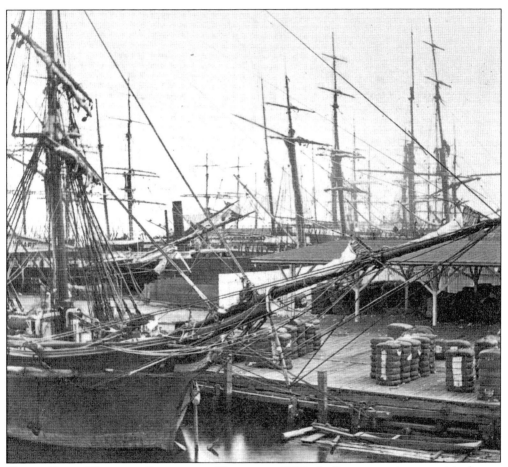

COOPER RIVER WHARVES, CHARLESTON HARBOR, C. 1870. As Reconstruction was visited upon the former Confederacy, the city of Charleston seemed to have a tougher time than most of the other war-ravaged Southern cities. Situated on a peninsula overlooking a large harbor at the mouths of two rivers, the city attempted to use its geographical advantages to recapture its former status as the premier commercial port of the Southeast. Even with thousands of bales of cotton and thousands of sacks of rice beginning to move again through the port city on its way to distant destinations, it would be many years before Charleston would be even a semblance of her former self. This view shows bales of cotton sitting on the Cooper River wharves, waiting to be loaded onto cargo ships. (Standard Series.)

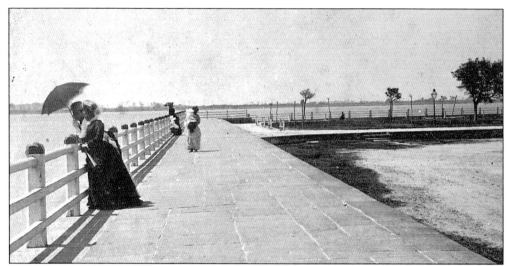

EAST BATTERY PROMENADE, C. 1880. As the city rebuilt, Charleston again began to attract visitors to its fair confines. Here, two ladies pause on the East Battery promenade to enjoy the sights and sounds of the harbor. Tourism was a vital ingredient in Charleston's bid to re-emerge from its wartime poverty. (O. Pierre Havens.)

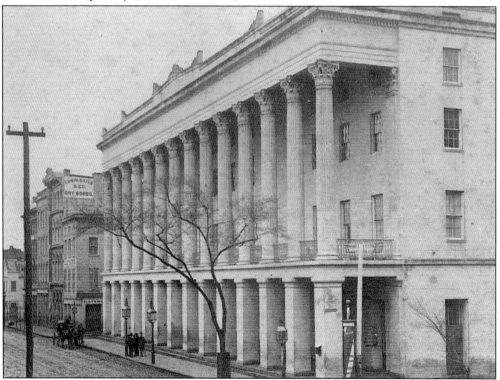

CHARLESTON HOTEL, 200 MEETING STREET, C. 1875. Some few lucky buildings looked much as they did when the war ended. The Charleston Hotel was one of those few that did not need major repairs or outright rebuilding. (See the wartime view on page 53). Finished in 1839, the Greek Revival structure and its 14 Corinthian columns presented an imposing facade on Meeting Street for many years. (Jesse A. Bolles.)

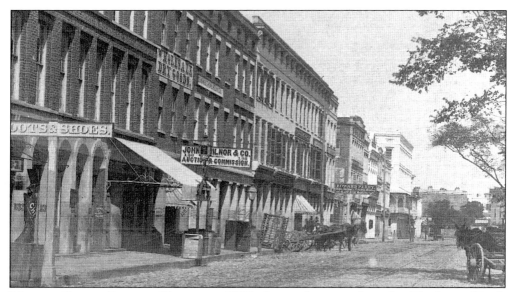

MEETING STREET, LOOKING NORTH, C. 1875. Across the street from the Charleston Hotel, many merchants had again set up shop to offer their wares to the public. The reinvigoration of trade gave confidence to the citizens that their beloved city would one day recover its former greatness. (George N. Barnard.)

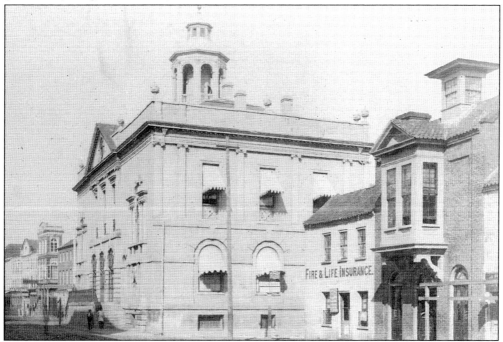

EXCHANGE BUILDING, EAST BAY STREET, C. 1875. Erected in Colonial times, the Exchange Building, located at the intersection of East Bay and Broad Streets, seems to have regained its former stateliness. Broken windows have been replaced and other damage from the war has been repaired. During the 200-plus years of its existence, the structure has served as a prison, a customs house, and a post office; it now functions as a tourist center and museum. (George N. Barnard.)

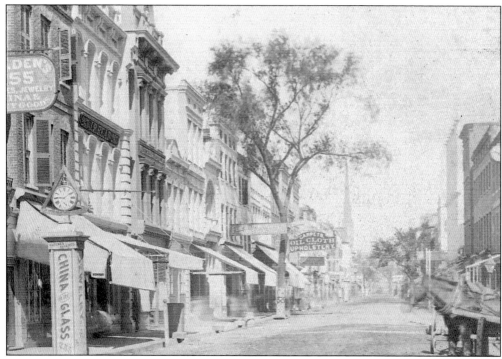

KING STREET, FROM THE INTERSECTION OF BEAUFAIN STREET, LOOKING NORTH, C. 1875. King Street merchants were among the first to revitalize their businesses. War seems to have been a distant memory, from the looks of Charleston's commercial district in the mid-1870s. Even with the prosperous-looking storefronts and fancy signs testifying to the city's attempts at revitalization, Charleston would remain a poor city for some time. (George N. Barnard.)

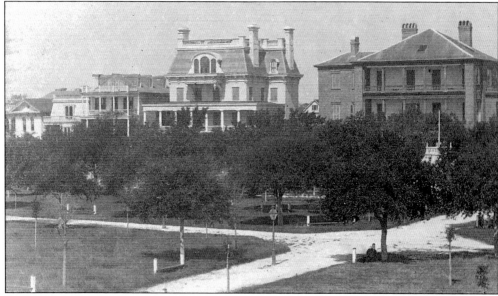

SOUTH BATTERY, C. 1875. This photograph was taken from the old bathhouse that sat upon a pier projecting from the Battery into the Ashley River. The Battery seems quite serene in this view, the cannon having been replaced by park benches and trees. (George N. Barnard.)

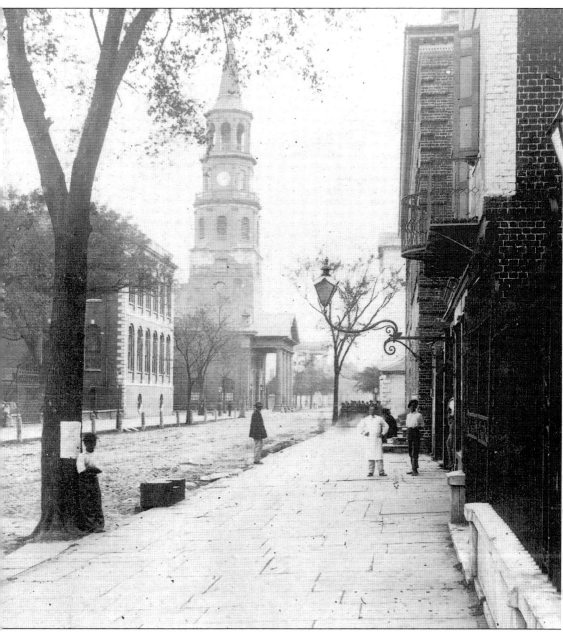

MEETING STREET, LOOKING SOUTH, C. 1868. The presence of the proud shopkeeper and prospective customers show that business in Charleston has recovered somewhat. The throng of people standing behind the shopkeeper at the far end of the street seems to be waiting for something, perhaps a trolley car, the tracks of which are visible in the roadbed. The Charleston City Hall and Saint Michael's Church are visible across the street. Note that the spire of Saint Michael's had not yet been whitewashed. It had been painted black during the Civil War to make it less apparent to the Union artillerymen who used it as a landmark when aiming their cannon. The spire had also been used as a lookout tower and signal station by Confederate troops. The church itself had been hit four separate times by Federal artillery firing from Morris Island, but had suffered no lasting damage. (George N. Barnard.)

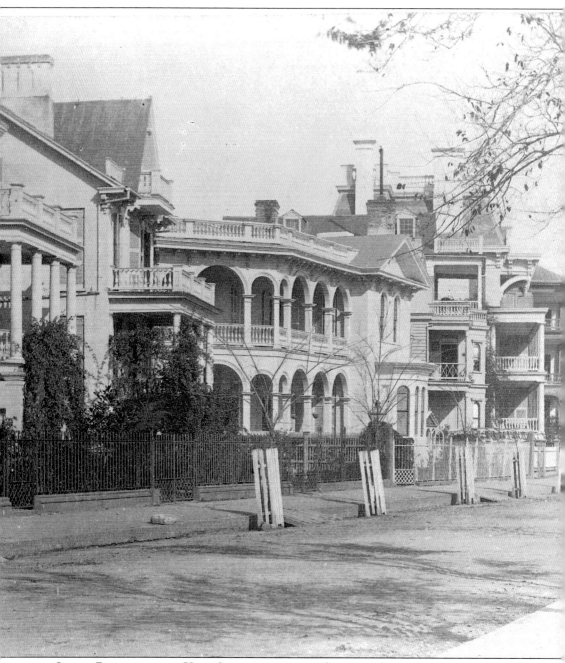

SOUTH BATTERY, FROM KING STREET, C. 1875. This view shows the fine homes on South Battery to have been restored to their former elegance. The owners of these homes, who once stood on their piazzas and witnessed the initial bombardment of Fort Sumter, and who were later forced to desert their homes due to Union shelling of the city, were now able to sit in peace and watch life unfold across the street at White Point Gardens. These homes look much the same today, over 120 years later, thanks to the continuing care of their owners. Note the house at 26 South Battery, which is pictured in an early post-war photograph on page 43, during its use as General Hatch's headquarters. (George N. Barnard.)

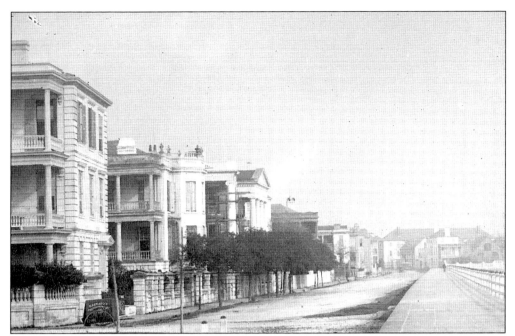

CORNER OF EAST BATTERY AND SOUTH BATTERY, LOOKING NORTH, C. 1875. Photographer George N. Barnard captured this view of East Battery. The remains of the Blakely cannon (see page 42) have been supplanted by Barnard's portable darkroom, which is shown below. (George N. Barnard.)

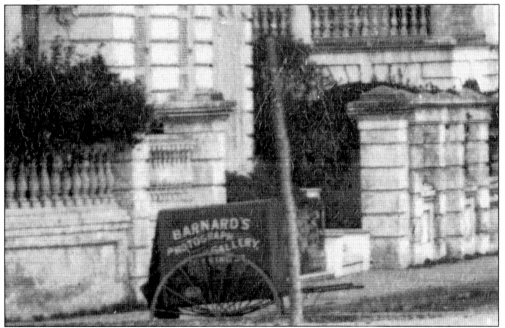

CORNER OF EAST BATTERY AND SOUTH BATTERY, C. 1875. A blow-up taken from the view above gives us a hint of what photography was like in the nineteenth century. Equipment such as this was required by photographers when they took photos outside of the studio. (George N. Barnard.)

CORNER OF MEETING AND BROAD STREETS, c. 1875. Saint Michael's Church and the Charleston City Hall form two corners of the famed "Four Corners of Law," located at the junction of Meeting and Broad. The other two corners, not seen in this photo, are the Charleston County Courthouse and the Federal Courthouse-Post Office, which was not finished until 1896. (George N. Barnard.)

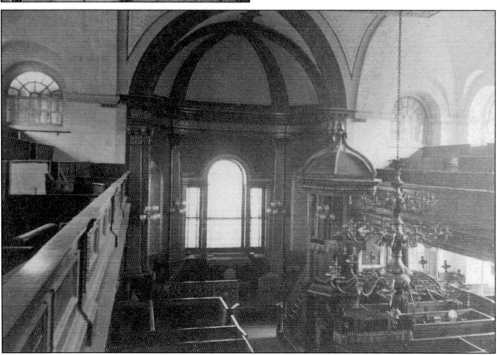

INTERIOR OF SAINT MICHAEL'S PROTESTANT EPISCOPAL CHURCH, c. 1875. The oldest church building in the city, Saint Michael's was begun in 1752 and completed in 1761. The edifice has withstood assaults over the years from hurricanes, tornados, earthquakes, and enemy bombardments. This view of the interior was taken before the fine, stained-glass window of Saint George and the Dragon was added to the church. (F.A. Nowell.)

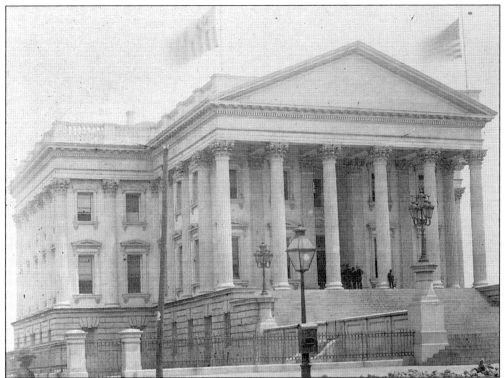

CUSTOM HOUSE, EAST BAY STREET, C. 1880. The cornerstone of the newly completed Custom House was laid in 1853, but work had to be suspended during the war years. Construction was recommenced after the war and the building was finished in 1879, right before this photo was taken. (George La Grange Cook.)

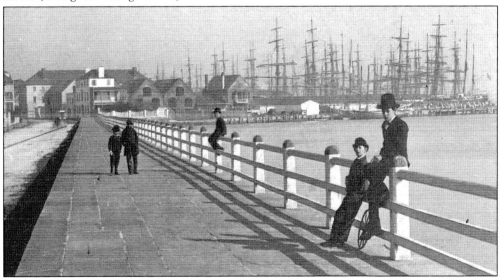

EAST BATTERY, LOOKING NORTH, C. 1875. A reminder of the source of Charleston's hope for the future, ships docked at the wharves are visible in this view taken from the East Battery promenade. According to the photo's caption, the ships had just arrived in port from Florida. (George N. Barnard.)

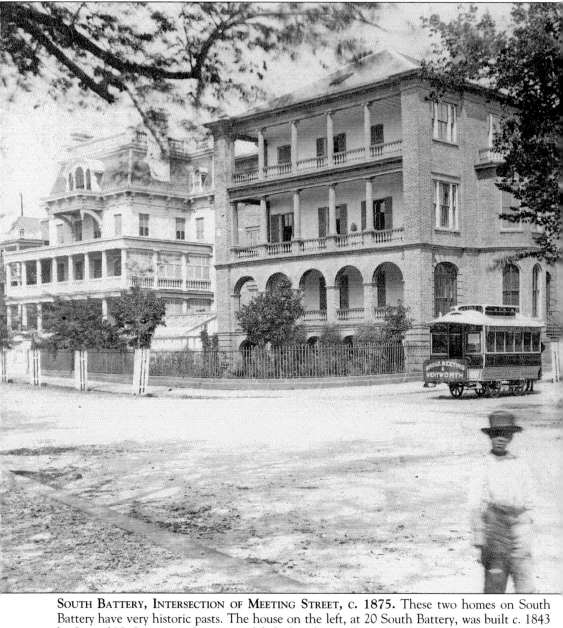

SOUTH BATTERY, INTERSECTION OF MEETING STREET, C. 1875. These two homes on South Battery have very historic pasts. The house on the left, at 20 South Battery, was built c. 1843 by Samuel N. Stevens and was remodeled after the war by Colonel Richard Lathers. Lathers, a native of Georgetown, had gone to New York as a young man and had become wealthy as a cotton broker and banker. During the Civil War, he served in the Union army. After the war he returned to the South and purchased this house. Inviting many military and political leaders to elegant receptions at his mansion, he hoped to bring about a quick reconciliation between Northerners and Southerners. A few years later, discouraged, he gave up the attempt and returned to the North. The home on the right, at 1 Meeting Street, was built c. 1846 and at one time housed the Ross Museum, containing the art collections of the Ross family. Note the trolley parked at the intersection in this interesting period view. (George N. Barnard, photographer; courtesy of Marvin Housworth.)

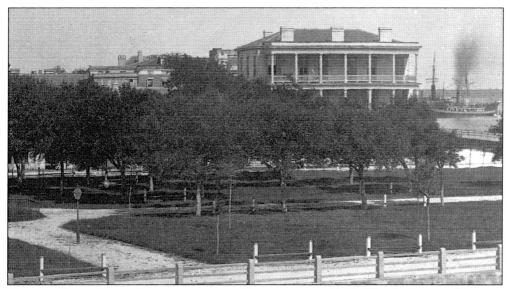

VIEW OF WHITE POINT GARDENS FROM THE BATHHOUSE, C. 1870. The de Saussure House at 1 East Battery towers over White Point Gardens and the young live oak trees in this view. Built in 1850 by Thomas A. Coffin and later sold to Louis de Saussure, the house served as an observation point for many prominent Charlestonians who watched the opening salvos of the Civil War from its second-floor piazza.

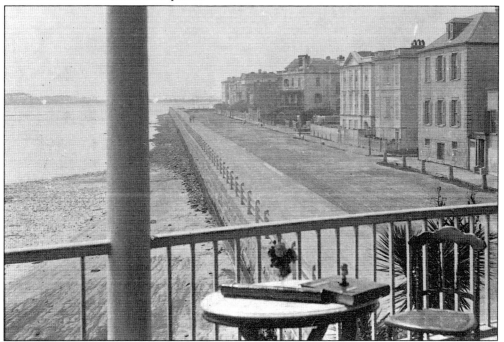

EAST BATTERY, LOOKING SOUTH, C. 1870. Taken from the second-floor piazza of the Missroon House at 40 East Battery, this photo shows the upper end of East Battery. Owned by the family of Captain Missroon at the time, the house later became the Shamrock Terrace Hotel, and today belongs to the Historic Charleston Foundation. (George N. Barnard, photographer; courtesy of Marvin Housworth.)

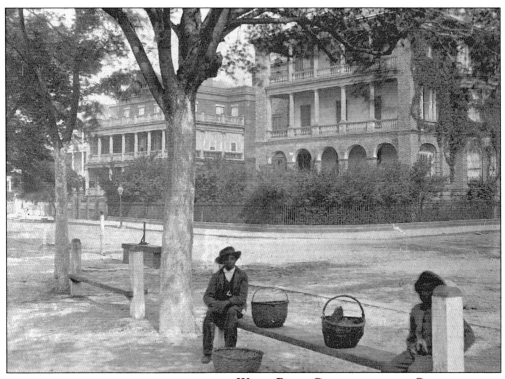

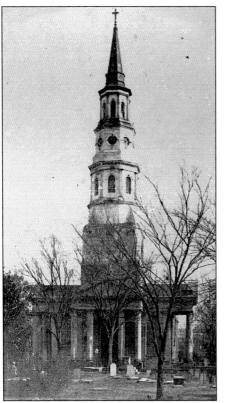

WHITE POINT GARDENS AND THE CORNER OF MEETING STREET AND SOUTH BATTERY, c. 1875. Street vendors, offering freshly-killed chickens for sale, wait for potential customers in this view taken at White Point Gardens. Behind the vendors appears the aforementioned fine homes at 1 Meeting Street and 20 South Battery. (George N. Barnard.)

SAINT PHILIP'S EPISCOPAL CHURCH, 146 CHURCH STREET, c. 1870. Begun in 1835 to replace an earlier structure destroyed by fire, Saint Philip's Church houses the oldest congregation in Charleston. The building sustained some damage during the Civil War, but had been repaired by the time this photo was taken. (The Southern Series.)

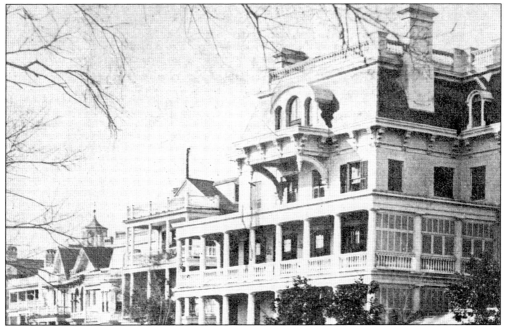

SOUTH BATTERY, C. 1875. The mansion at 20 South Battery was built in 1843 by Samuel N. Stevens, a prosperous cotton factor. It was remodeled in 1870 for Colonel Richard Lathers (see page 70), and was later purchased by Andrew Simonds, a prominent local banker. A portion of the home is now utilized as a small inn. (Stereoscopic Gems.)

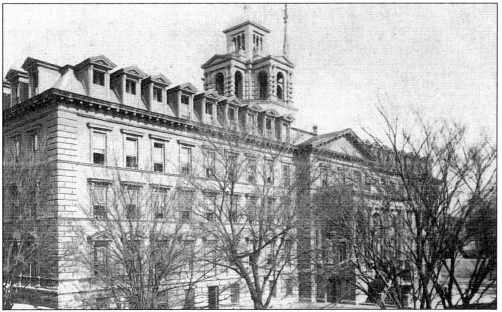

THE ORPHAN HOME, C. 1870. Located at 160 Calhoun Street and begun in 1792, the Orphan Home was completed in 1794. Known to be the earliest municipally supported orphanage in the United States, the Orphan Home housed thousands of children during its long existence. The building was torn down in the 1950s and the statue of Charity which had graced its roof now resides in The Charleston Museum. (The Southern Series.)

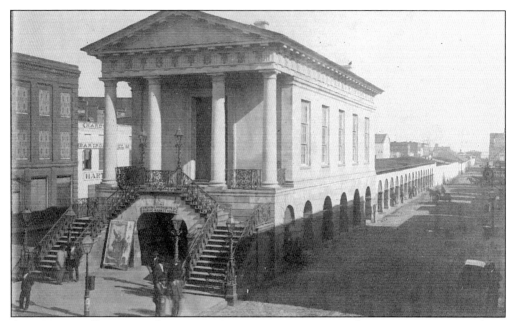

CITY MARKET BUILDING, CORNER OF MARKET AND MEETING STREETS, C. 1875. Built in 1841, the City Market stands on land donated by the Pinckney family. The donation was made with the stipulation that the property would revert to the family if used for any other purpose than a city market. The second floor of the building houses the Confederate Museum and is the headquarters of the Charleston Chapter of the United Daughters of the Confederacy. (George N. Barnard.)

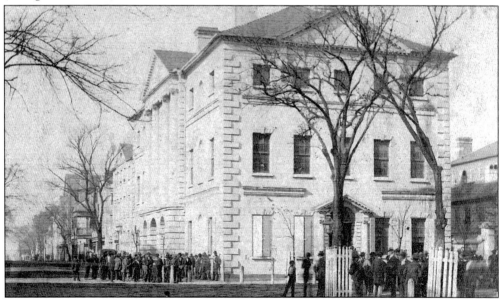

CHARLESTON COUNTY COURTHOUSE, CORNER OF MEETING AND BROAD STREETS, C. 1870. In this view, a large crowd has congregated outside the County Courthouse, perhaps awaiting the trolleys. The building was completed in 1792 on the site of and using the foundation of the original South Carolina State House, which had been destroyed by fire in 1788. The building is one of the "Four Corners of Law" of downtown Charleston. (The Southern Series.)

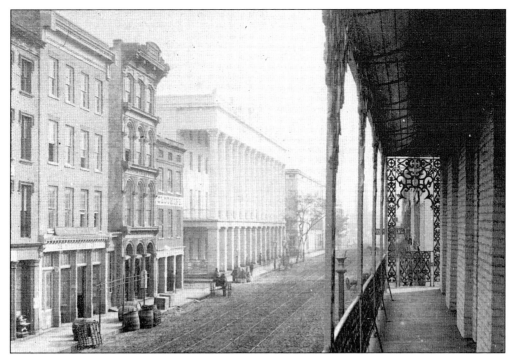

MEETING STREET, LOOKING SOUTH, C. 1875. In this view, taken from the balcony of the Pavilion Hotel, the competing Charleston Hotel can be seen in the distance. Again, note the presence of the trolley tracks running down the middle of Meeting Street. (S.T. Souder.)

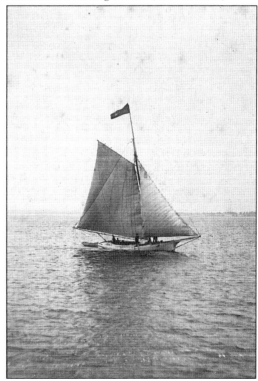

YACHT *ELEANOR*, CHARLESTON HARBOR, C. 1872. It is certain that enjoyable pursuits were not missing from post-war Charleston. Here, the yacht *Eleanor* takes her crew and passengers on a delightful cruise in the harbor. Pleasure boating, which had ceased during the war, again became popular in Charleston Harbor. (S.T. Souder.)

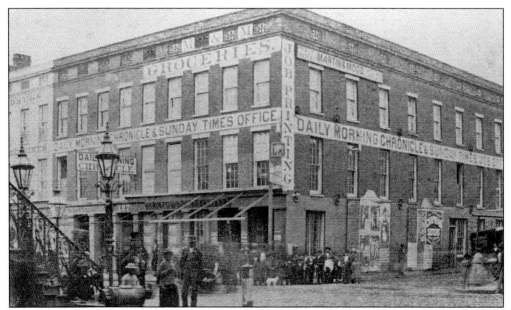

SOUTHWEST CORNER OF MARKET AND MEETING STREETS, C. 1875. The grocery store of Martin & Mood and the offices of the *Daily Morning Chronicle & Sunday Times* shared space in this building at 183 Meeting Street. The view can be dated by the name of the newspaper; the *Daily Morning Chronicle* succeeded the *Daily Charleston Bulletin*, running from June of 1873 until September of 1875. (The Southern Series; courtesy of the South Caroliniana Library.)

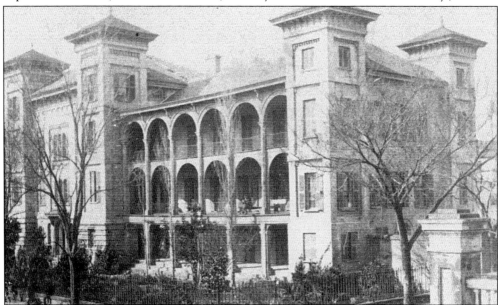

ROPER HOSPITAL, QUEEN STREET, C. 1870. Designed by famous Charleston architect Edward C. Jones, the old Roper Hospital was completed in 1852. For almost 35 years, it served the medical needs of the residents of Charleston, until the 1886 earthquake hit the Charleston area. The princely Italianate structure was heavily damaged in the quake, and the matching wings were demolished at some point later in time. The central portion remained until Hurricane Hugo destroyed it in 1989. (S.T. Souder, photographer; courtesy of the South Caroliniana Library.)

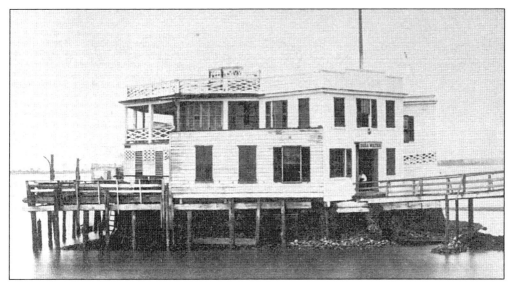

BATHHOUSE, WHITE POINT GARDENS, c. 1870. In this view, a sign mounted above the entrance to the bathhouse advertises soda water to thirsty tourists. Appearing on maps as early as 1833, the building served as a Confederate lookout post and signal station during the Civil War. After several years as an eyesore, the structure was demolished in 1881. (E. & H.T. Anthony, publisher; courtesy of the South Caroliniana Library.)

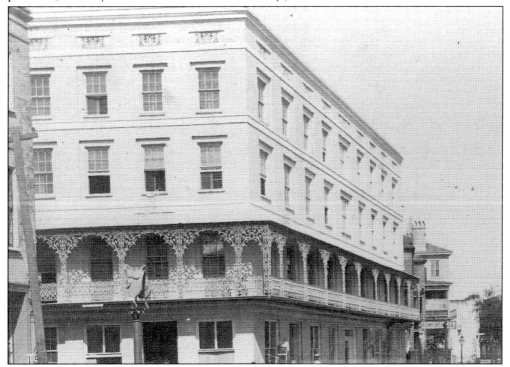

PAVILION HOTEL, MEETING STREET, c. 1875. Fine ironwork appears on the second-floor porch in this photo of the Pavilion Hotel. Erected in the 1830s on the corner of Meeting and Hasell Streets, the hotel served guests for many years. Later incarnations were as the Saint Charles Hotel and the Argyle Hotel. (Courtesy of Joseph Matheson.)

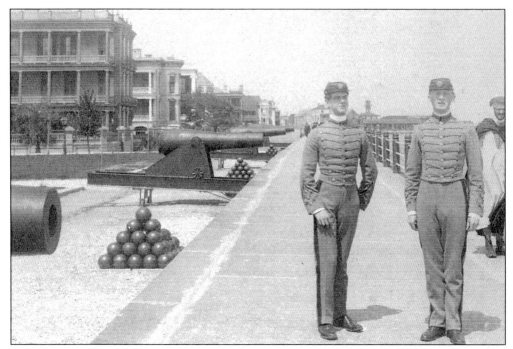

EAST BATTERY PROMENADE, C. 1900. As the 1800s came to a close, Charleston's period of rebuilding had brought the city to the brink of the new century. Perhaps echoing the city's refound vigor, two proud Citadel cadets have posed at attention for the camera. Cannon and cannonballs have reappeared on the Battery, only this time for show. Also, note the foreign traveler in the background. (Underwood & Underwood.)

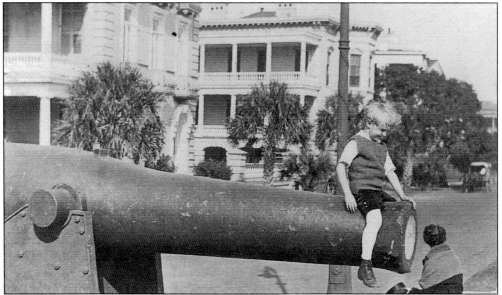

THE BATTERY, CORNER OF EAST BATTERY AND SOUTH BATTERY, C. 1925. The old guns on the Battery have long been a fascination to young and old alike. This photo was taken by an amateur photographer, a traveling Vaudevillian whose show appeared in Charleston sometime in the 1920s.

Five

A Bird's-Eye View

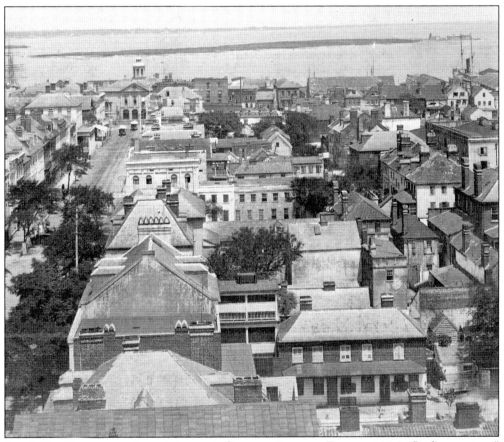

Bird's-Eye View, from Saint Michael's Church, Looking East, c. 1875. "Bird's-eye views" were very popular in the late 1800s. There was no air travel, no skyscrapers graced the skyline of Charleston, and most people were not daring enough to climb up a church steeple. Therefore, photographs taken from such a vantage point held a certain mystique for the average person. In this view, taken from Saint Michael's bell tower, the eastern end of Broad Street, terminating at the Exchange Building, is visible at the left. Note the two horse-drawn trolleys directly in front of that building. Also, note Shute's Folly Island in the distance, with Castle Pinckney located at its eastern end (upper right of the photo). (George N. Barnard.)

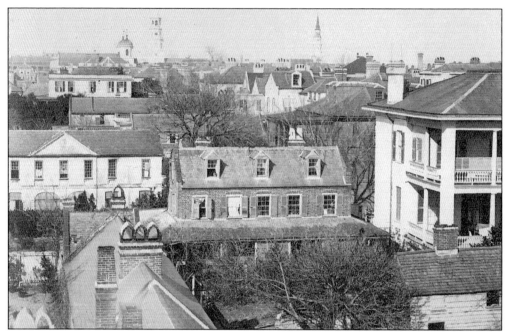

BIRD'S-EYE VIEW, FROM SOUTH BATTERY, C. 1870. The steeples of the First Presbyterian Church, Saint Michael's Church, and Saint Philip's Church can be seen in the distance in this photo. Also, the homes on Lamboll Street and Ladson Street are visible in the mid-distance. This photo was probably taken from the upper story of the home at 20 South Battery. (The Southern Series.)

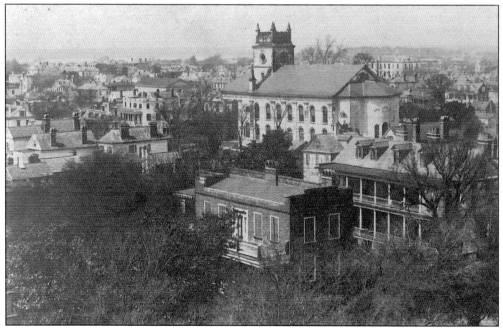

BIRD'S-EYE VIEW, FROM THE ORPHAN HOME, LOOKING WEST, C. 1875. The back of the Episcopal Cathedral of Saint Luke and Saint Paul and other buildings west of King Street and north of Calhoun Street appear in this view. (Kilburn Brothers.)

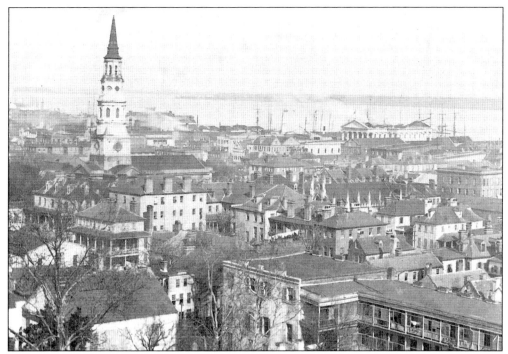

PANORAMA FROM SAINT MICHAEL'S CHURCH, LOOKING NORTHEAST, C. 1870. The bell tower of Saint Philip's Church dominates the skyline in this photo. The Custom House, its roof not quite finished, is visible in the distance to the right. Also, the Confederate Home and Washington Park can be seen in the foreground. (The Southern Series.)

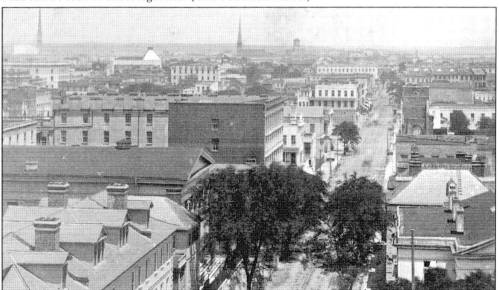

BIRD'S-EYE VIEW, FROM SAINT MICHAEL'S CHURCH, LOOKING NORTH, C. 1875. The business district of Meeting Street is featured in this view, showing the Hibernian Hall, the Mills House, City Hall, and the Fireproof Building. The two steeples in the distance (on the left side of the photo) are those of Citadel Square Baptist Church and Saint Matthew's Lutheran Church. (F.A. Nowell.)

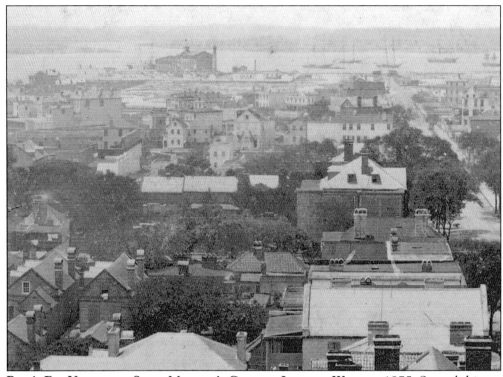

BIRD'S-EYE VIEW, FROM SAINT MICHAEL'S CHURCH, LOOKING WEST, C. 1875. Several ships at anchor in the Ashley River can be seen in this photo, as can the old Chisolm Rice mill, which was located at the western end of Tradd Street. The Wappoo Cut, the northeastern tip of James Island, and the mainland west of the Ashley River are also visible in the far distance. (The New York View Co.)

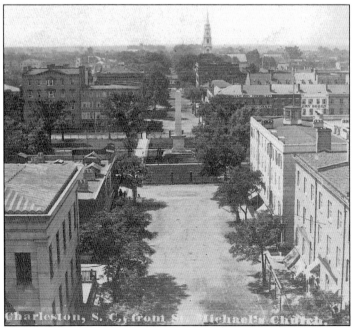

"CHARLESTON, S.C., FROM SAINT MICHAEL'S CHURCH." So states the caption on this c. 1875 view, but you can't always believe what you read. This view staunchly represents itself as being taken in Charleston, but this is not correct, as no such buildings existed which could match those pictured. The photo is actually one of Bull Street in Savannah. Note the arrangement of the "squares" in the downtown district. (The New York View Co.)

Six

GARDENS, PARKS, AND CEMETERIES

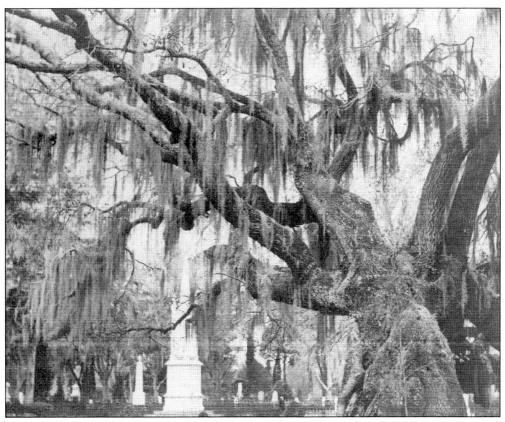

VIEW IN MAGNOLIA CEMETERY, C. 1885. Live oaks and Spanish moss have been the quintessential images of the Lowcountry for many years. Visitors and residents alike never fail to be impressed by the beauty of the union of these two native species. The low-hanging branches of the live oak combine with the ethereal quality of the hanging moss to offer the viewer an inviting image of peacefulness and serenity. And such was the intention of the founders of Magnolia Cemetery, when in 1849 they came together to form a company for its establishment. Work on "The City of the Silent," as it was called, was begun the next year. The old Magnolia Umbra plantation on the Cooper River just north of the city of Charleston was purchased, and the site was prepared by the planting of trees and laying out of the burial plots and the winding paths. (B.W. Kilburn.)

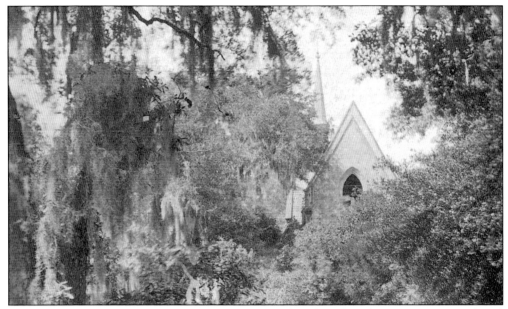

CHAPEL, MAGNOLIA CEMETERY, C. 1875. A pond, a chapel, and verdant vegetation combined to soothe the weary soul at the cemetery, located to the north of the city in the "neck area" of the peninsula. Noted Charlestonian Edward C. Jones was the architect who designed Magnolia, and included in his plans were a massive gateway, a receiving house, and the chapel (seen above).

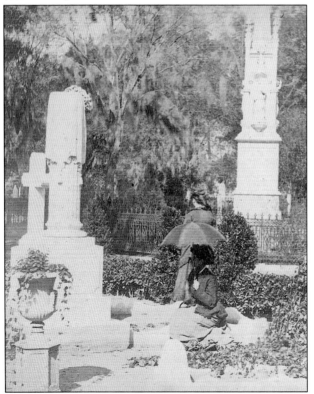

HOWELL PLOT, MAGNOLIA CEMETERY, C. 1875. A young woman with an umbrella sits at the grave of Adeline Wilhelmina Howell, who died February 10, 1860, at the tender age of 18. The monument states that she was the only daughter of Sidney S. and Adeline M. Howell. The Jones Monument is visible in the background. (F.A. Nowell.)

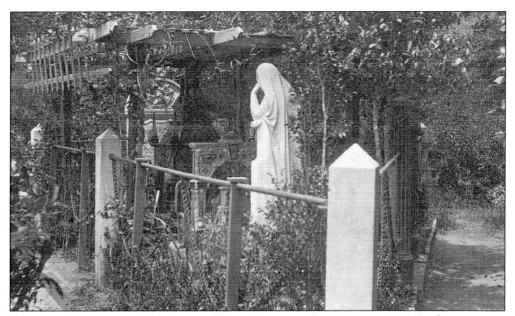

GRAVE OF CAPTAIN AND MRS. ALFRED WISE, MAGNOLIA CEMETERY, C. 1870. In this view, one of the few statues in the cemetery depicting the human form stands as if in silent meditation. Maria Wise, the wife of Captain Alfred Wise, died at the age of 50 on April 22, 1861, just a few days after the Civil War began. Captain Wise followed her a few years later, dying in January of 1867 at age 56. (Quinby & Co.)

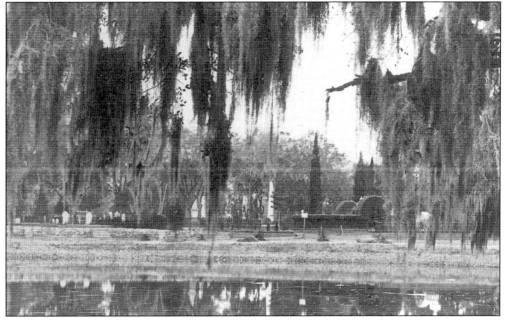

VIEW IN MAGNOLIA CEMETERY, C. 1880. The New England Society Lot and its monument can be seen reflected in the lake in this view of Magnolia Cemetery. Other memorials placed at the cemetery over the years include those for the Washington Light Infantry, the C.S.S. *Hunley*, Colonel William Washington, and the Confederate soldiers who died in the defense of Charleston. (B.W. Kilburn.)

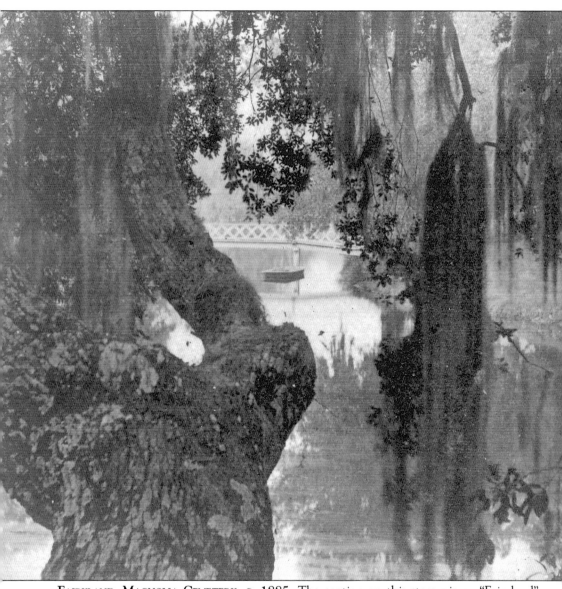

FAIRYLAND, MAGNOLIA CEMETERY, C. 1885. The caption on this stereoview—"Fairyland"—captures the essence of this peaceful scene. Many famous Charlestonians have been buried in said "Fairyland." Robert Barnwell Rhett, a legislator and strong advocate of secession, who succeeded John C. Calhoun as a U.S. senator, is one. Another is Horace L. Hunley, the inventor of the C.S.S. *Hunley*, the first submarine used in warfare. Also buried in Magnolia is the second crew of the *Hunley*, all of whom perished when the miniature sub sank in a practice run. In addition, there are over 800 Confederate soldiers interred in the state's only officially recognized Confederate cemetery. Protected now in death by two naval guns and a forever vigilant bronze infantryman, these soldiers were the ones who had laid down their lives on James Island and Morris Island and in the various forts and batteries around Charleston. (Littleton View Co.)

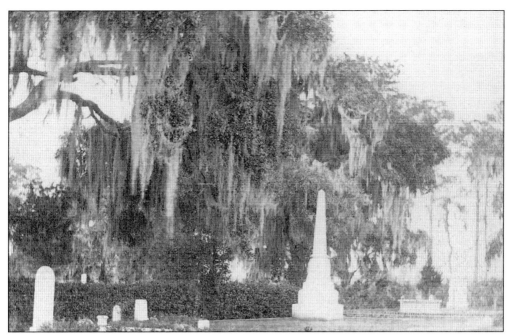

NEW ENGLAND SOCIETY'S LOT, MAGNOLIA CEMETERY, C. 1875. The New England Society of Charleston was organized in 1819 for the purpose of aiding "such of the sons or their descendants of New England as might be arrested by the hand of disease or chill penury in this city." In 1871, the society dedicated a section of Magnolia as a burial place for New Englanders and their descendants. (The Southern Series.)

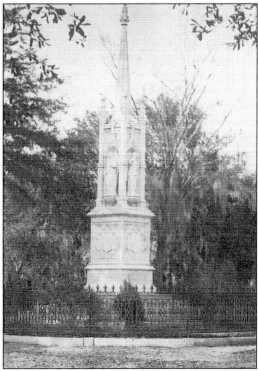

JONES MONUMENT, MAGNOLIA CEMETERY, c. 1870. This memorial was erected as a "tribute of affection to a beloved husband" by Sarah J. Jones in memory of her husband. Elbert P. Jones died in 1852, but had been living in San Francisco for the previous six years. That chronology would have placed him there right in the middle of the California Gold Rush. Perhaps that was the origin of the wealth that enabled his wife to erect such a massive and intricate monument. (The Southern Series.)

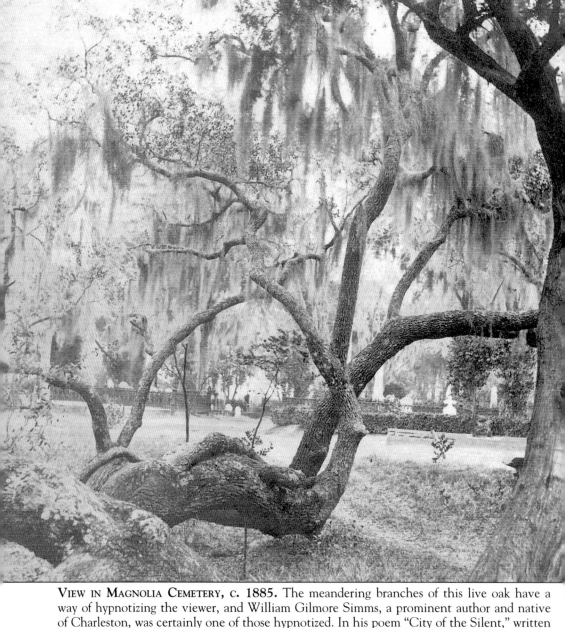

VIEW IN MAGNOLIA CEMETERY, C. 1885. The meandering branches of this live oak have a way of hypnotizing the viewer, and William Gilmore Simms, a prominent author and native of Charleston, was certainly one of those hypnotized. In his poem "City of the Silent," written especially to commemorate the dedication of the cemetery in November of 1850, Simms penned the following: "Yet, not to these alone, the gifted, great; Our sacred shrines and shades we consecrate; Their tombs, the landmarks to the patriot's eye; With great historic names that cannot die." Simms's words were certainly prescient, as many historic persons have been buried at Magnolia, among them five Confederate Generals—James Conner, Arthur Middleton Manigault, C.H. Stevens, Micah Jenkins, and Roswell S. Ripley. Other notable leaders include Robert Barnwell Rhett, Horace L. Hunley, William Gregg, John H.L. Fuller, Thomas Bennett, Hugh Swinton Legare, William Ashmead Courtenay, George Alfred Trenholm, and even poet William Gilmore Simms himself. (B.W. Kilburn.)

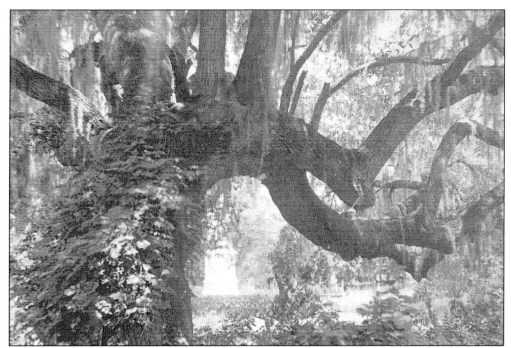

OAKS, MAGNOLIA CEMETERY, C. 1885. An ancient live oak in combination with Spanish moss, some wisteria, and a distant monument give this photo a tunnel effect when viewed through a stereoviewer. Some of the live oaks at Magnolia are hundreds of years old and predate even the Magnolia Umbra plantation. (F.A. Nowell.)

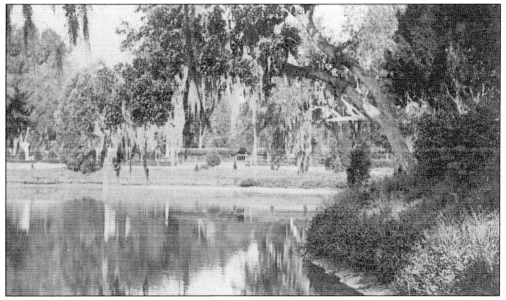

MAGNOLIA CEMETERY, C. 1890. "Midst sacred gloom of trees, midst shadows meet; That mingle well the solemn with the sweet; Where banks of thyme and daisy scent the ground; While waters, murmur nigh with slumberous sound," wrote William Gilmore Simms in his dedicatory poem to Magnolia cemetery. He certainly was able to capture the essence of the cemetery in his verse, as the above photo demonstrates. (B.W. Kilburn.)

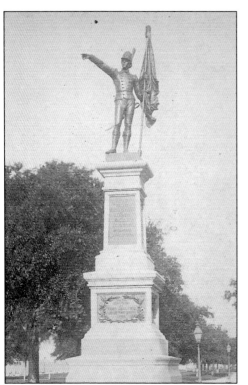

JASPER MONUMENT, WHITE POINT GARDENS, c. 1875. Sergeant William Jasper, the Revolutionary War hero of Fort Moultrie, presides over East Battery in this view. Jasper was honored for his heroics when, braving enemy fire, he leapt over the walls of the fort to remount the downed flag. He was later killed at the Battle of Savannah, once more attempting to replace the fallen flag. (F.A. Nowell.)

STATUE OF WILLIAM PITT, WASHINGTON SQUARE, c. 1895. The statue of William Pitt, seen at right, was this country's first monument honoring a public citizen. Originally erected at the intersection of Broad and Meeting Streets, it was later moved to the yard of the Orphan Home, where the children humorously referred to the toga-clad figure as "George Washington getting out of bed." In 1891, the statue was moved to Washington Square, but now resides in The Charleston Museum. The statue honors Pitt as a champion of the cause of the American colonists against the Stamp Act. (Courtesy of the South Caroliniana Library.)

MAGNOLIA-ON-THE-ASHLEY,
c. 1875. Magnolia Plantation,
also known as Magnolia Gardens,
and not to be confused with
Magnolia Cemetery, is located on
the banks of the Ashley River. The
Reverend J.G. Drayton started the
gardens at Magnolia Plantation
in 1843 as an attempt to "create
an earthly paradise in which my
dear [wife] Julia may forever forget
Philadelphia and her desire to
return there." (O. Pierre Havens.)

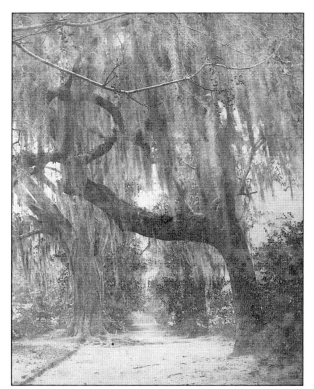

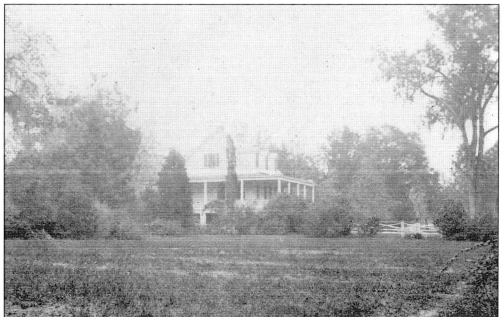

MAGNOLIA PLANTATION, ASHLEY RIVER, C. 1880. Drayton's plantation home, seen above, was not original to the property. Reverend Drayton had it moved to the site in 1873 to replace the home burned by Union troops in 1865. That prior house was not original either, being a replacement for an earlier home also destroyed by fire. (George N. Barnard; courtesy of Joseph Matheson.)

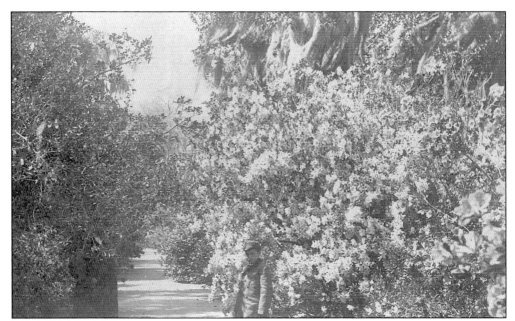

IN MAGNOLIA GARDENS, C. 1895. Large azaleas, some as old as 150 years, grace the walks of Magnolia Gardens. Importing numerous specimens of Camellia *Japonica* and Azalea *Indica*, Drayton adopted an informal "Romantic" treatment for his plantings. With an emphasis on a natural setting, wide footpaths wind beneath the live oaks and magnolias through an apparently random planting of azaleas and camellias. (Keystone View Company.)

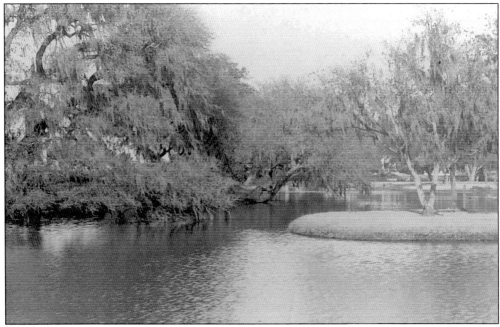

LAKE, MAGNOLIA GARDENS, C. 1897. The lake at the Gardens offers a peaceful spot for relaxation. In 1870, Reverend Drayton opened the property to the public, giving all a chance to experience the beauty of what he had created. His creation remains open to visitors today. (Keystone View Company.)

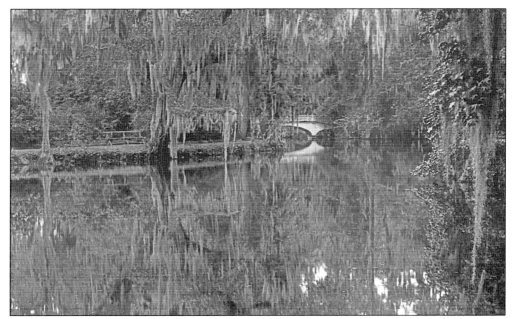

A BEAUTIFUL SCENE IN MAGNOLIA GARDENS, C. 1910. This wooden footbridge has been photographed so many times that it is virtually synonymous with Magnolia Gardens. The idyllic scene radiates serenity and makes the Gardens one of the most visited attractions in Charleston. (Keystone View Company.)

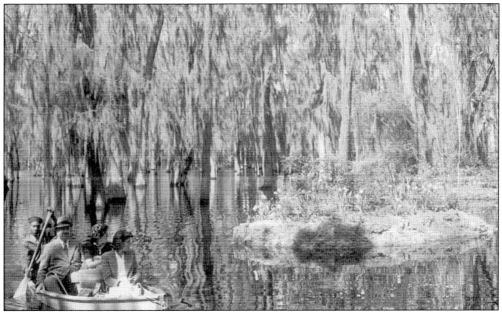

CRUISING THE WATERS OF CYPRESS GARDENS, C. 1935. Offering cypress trees instead of live oaks, Cypress Gardens has been another favorite retreat of countless visitors to the Lowcountry. Founded in 1927 by Benjamin R. Kittredge, owner of Dean Hall Plantation, the Gardens comprise some 250 acres of cypress swamp that have been carefully landscaped into a marvelous visual tableau. In addition to the native cypress, thousands of azaleas were set out, along with narcissus, daffodils, camellias, and daphne odora. (Keystone View Company.)

THE GREAT TEA ROSE, CHARLESTON, C. 1890. The downtown area, especially the area nearest White Point Gardens, is also known for its wonderful garden spaces, yet on a much smaller scale. Beautiful, walled gardens predominate among the old homes, as evidenced by the giant tea rose in the view above. (B.W. Kilburn.)

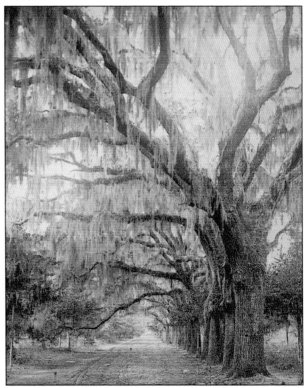

LIVE OAKS, C. 1870. The live oak *allee* has always been an essential part of the mystique surrounding the Southern plantation. The standard *allee* was formed by live oaks planted along one or both sides of the driveway to the plantation's main house, forming a living tunnel through which visitors had to pass. Some of the surviving *allees* were planted by South Carolina's earliest settlers, and now contain trees over 300 years old. (J.N. Wilson, photographer; courtesy of Joseph Matheson.)

94

Seven

AROUND THE
LOWCOUNTRY

PALMETTO TREE, UNKNOWN LOWCOUNTRY LOCATION, C. 1875. The palmetto tree has long been another widely recognizable image representative of the South Carolina Lowcountry. From the time of the Revolutionary War, when palmetto logs were used to construct Fort Moultrie, to the present day, when the palmetto graces our state flag and lines the streets of Charleston, one cannot help but think of South Carolina when one sees a palmetto tree. Photographer J.A. Palmer of Aiken captured this lone palmetto overlooking a marsh at an unknown location. (J.A. Palmer.)

SAINT JAMES EPISCOPAL CHURCH, GOOSE CREEK, C. 1875. The old Episcopal church at Goose Creek was completed about 1714. The parish was officially organized in 1707, but the original wooden building was removed to allow for the construction of the brick structure seen above. It is thought to be the oldest church in the state in anything close to its original condition. (Jesse A. Bolles.)

INTERIOR OF SAINT JAMES EPISCOPAL CHURCH, GOOSE CREEK, C. 1875. Note the British Coat of Arms above the pulpit in this view. Saint James Church is the only Anglican church in America still to display this symbol of the English monarchy. It is believed that this was the reason that British troops spared the church while burning most others they encountered during the Revolutionary War. (Jesse A. Bolles.)

CYPRESS FOREST NEAR ASHLEY RIVER, C. 1910. Spanish moss drapes the cypress trees in this Lowcountry forest in Dorchester County. Sometimes called "old man's beard," the hanging plant is really neither moss nor vine. Belonging to the same botanical family as the pineapple, the "moss" actually gains its sustenance from the air and not its host tree. (Keystone View Company.)

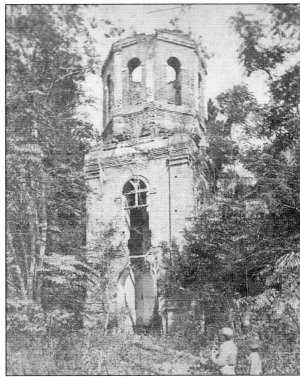

RUINS OF SAINT GEORGE'S CHURCH, NEAR THE ASHLEY RIVER, C. 1875. The old town of Dorchester was first settled in 1690, being founded by a group of missionaries from Dorchester, Massachusetts. There they built a fort, a blacksmith shop, a tavern, and the church seen at right. The settlers endured the mosquitoes and numerous other hardships for about 60 years before they decided to leave and return to New England. (George N. Barnard.)

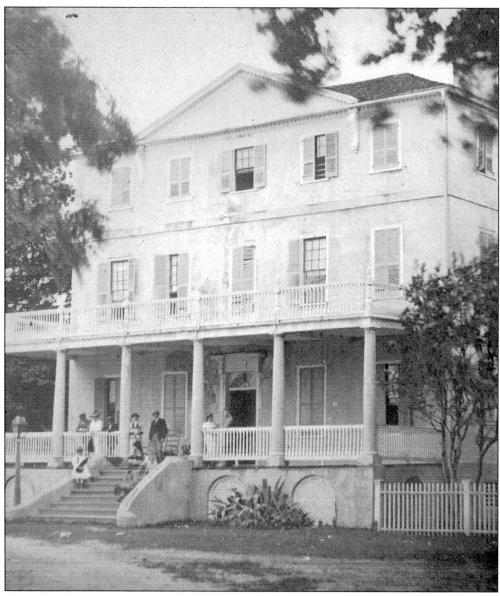

ANNEX TO SEA ISLAND HOTEL, BAY STREET, BEAUFORT, C. 1875. The label on the back of this stereoview advertised the Sea Island Hotel with the following: "One of the most popular resorts for tourists and invalids on the Atlantic Coast. Fine water view for miles; salt water baths, fishing, hunting and yachting, finest of society, excellent churches and schools. Climate equable, most salubrious and healthy. Rooms light, airy, and cheerful, table supplied with all a good market and the sea afford. Servants prompt and efficient." Built by the Elliott family prior to the Revolutionary War, the building was originally known as the William Elliott House. About 1890, after functioning as the annex to the Sea Island Hotel, the home was purchased by Admiral Lester A. Beardslee, the former commandant of the Port Royal Naval Station. Beardslee began calling his home "The Anchorage," and the building now houses a restaurant by that name. (Courtesy of Marvin Housworth.)

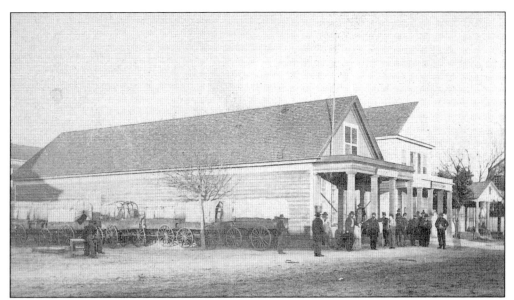

NORTH SIDE OF BAY STREET, INTERSECTION OF BAY AND WEST STREETS, BEAUFORT, c. 1863. In this wartime view, a crowd seems to be gathered outside John Flyler's general store. Flyler, whose mother was a Northerner, sympathized with the Yankee cause. As a result, his store was allowed to operate during the Union occupation, and, if one is to judge by this photo, flourished. (Sam Cooley, photographer; courtesy of Marvin Housworth.)

CHARLES STREET, LOOKING NORTH, BEAUFORT, c. 1875. A small African-American child appears in the middle of Charles Street in this view by Savannah photographers Wilson & Havens. Taken from the middle of the intersection with Bay Street, the photo shows what the north end of Charles Street looked like in 1875. (Wilson & Havens, photographers; courtesy of Marvin Housworth.)

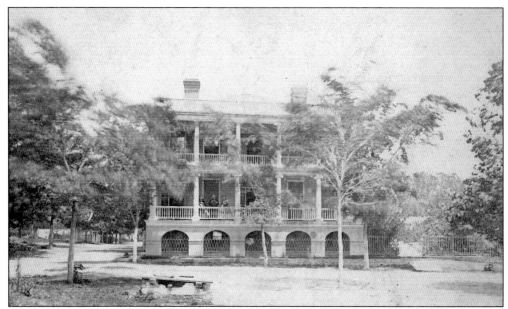

HOME OF EDMUND RHETT, BEAUFORT, C. 1865. Edmund Rhett was the brother of Robert B. Rhett, who was called the "Father of Secession" and who served as a member of the Confederate Congress. The home, which still stands, is officially called the Milton Maxcy House. It is also known as the "Secession House" because the Ordinance of Secession, which had to be ratified by each individual district in South Carolina, was signed in the house.

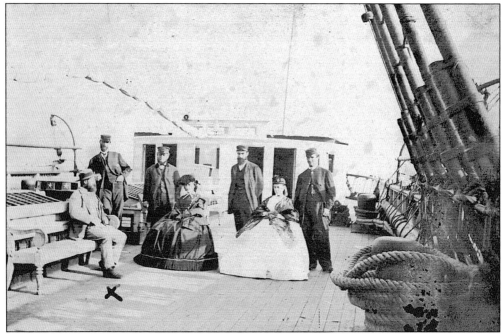

DECK OF THE STEAMER ARAGO, PORT ROYAL HARBOR, C. 1865. The steamer *Arago* functioned as a U.S. Government transport during the Civil War, making many trips between New York and Beaufort. In this post-war view, two ladies in hoop skirts and a gentleman pose with the crew for an amateur photographer.

SAINT HELENA EPISCOPAL CHURCH PARSONAGE, BEAUFORT, CHRISTMAS, 1876. Posed on the front porch in this view are Dr. and Mrs. Joseph Walker. A handwritten note on the reverse proclaims that Dr. Walker had been a pastor of the Episcopal Society for a total of 55 years. The parsonage building, which no longer exists, probably sat near the church itself, on either Church or North Streets. (Wilson & Havens, photographers; courtesy of Marvin Housworth.)

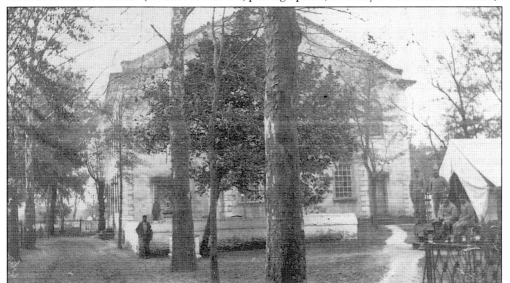

SAINT HELENA EPISCOPAL CHURCH, BEAUFORT, C. 1863. Union soldiers are present on the church grounds in this view because the church functioned as a Union hospital during the Civil War. Grisly stories have been told of wounded soldiers being operated on while lying upon the marble slabs of the graveyard. (Sam Cooley, photographer; courtesy of Marvin Housworth.)

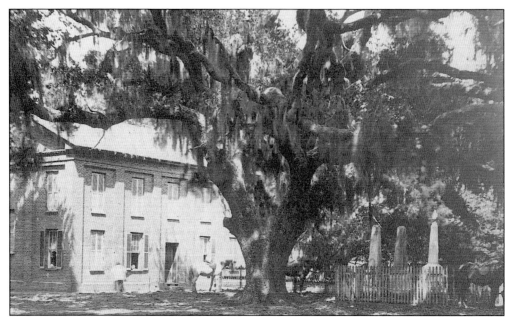

SAINT HELENA BAPTIST CHURCH, SAINT HELENA ISLAND, C. 1863. The Saint Helena Baptist Church, or "Brick Church" as it was popularly called, was built c. 1855 from funds donated by William Fripp. Fripp, who was nicknamed "Good Billy" because of this donation, is buried in the church's graveyard, as are many of the other prominent planters of the area. Deserted by its white members during the Civil War, the church became the home of an African-American congregation. (Sam Cooley, photographer; courtesy of Marvin Housworth.)

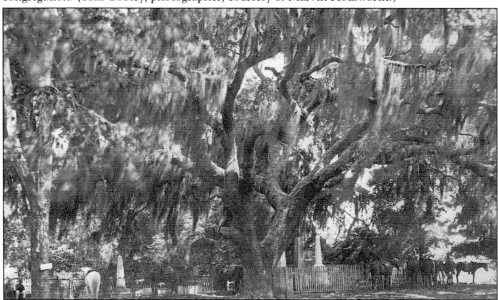

SAINT HELENA BAPTIST CHURCH, SAINT HELENA ISLAND, C. 1863. This photo presents a more extensive view of the graveyard of the "Brick Church." During Reconstruction the church became the focal point of educational, political, and religious activities for African Americans. And more recently, Martin Luther King Jr.'s "March on Washington" was planned right across the street at the Penn School. (Sam Cooley, photographer; courtesy of Marvin Housworth.)

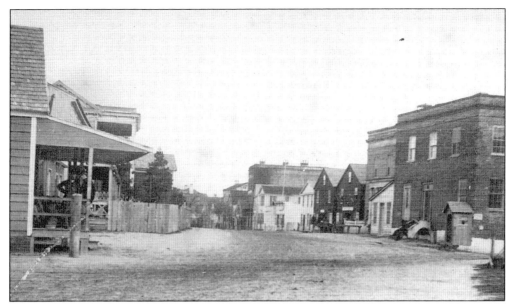

BAY STREET, LOOKING EAST, BEAUFORT, C. 1863. There did not seem to be much activity in downtown Beaufort when this view was taken. The Thomas Law Building, the Adams Express office, and the old Beaufort Hotel appear on the right side of this photo. Note the small sentry house which appears at the far right. (Sam Cooley, photographer; courtesy of Marvin Housworth.)

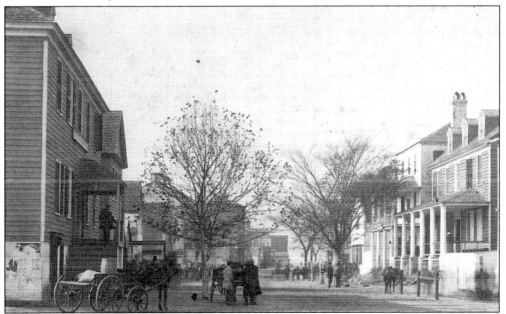

BAY STREET, LOOKING WEST, BEAUFORT, C. 1863. Downtown activity seems to have picked up in this view looking in the opposite direction. Facing west and taken from the intersection of Carteret and Bay, this photo reveals many buildings which no longer exist. A devastating fire in 1907 destroyed most of the Civil War-era buildings in the Bay Street-Carteret Street area. Started by some boys caught smoking in a cotton warehouse, the conflagration destroyed more than 40 buildings. (Sam Cooley, photographer; courtesy of Marvin Housworth.)

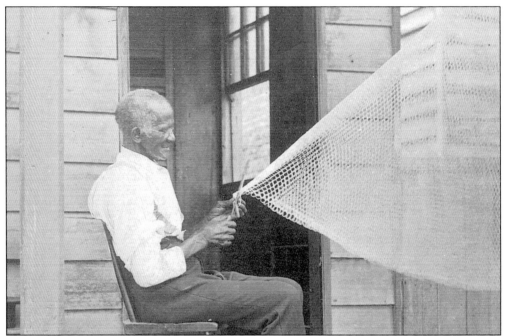

"UNCLE JIMMY," CHAMPION FISHERMAN, BEAUFORT, C. 1875. African Americans in the Beaufort area have carried on a long tradition of being expert fishermen. Here, a man known as Uncle Jimmy puts the finishing touches on a fine-looking fishnet. (O. Pierre Havens, photographer; courtesy of Marvin Housworth.)

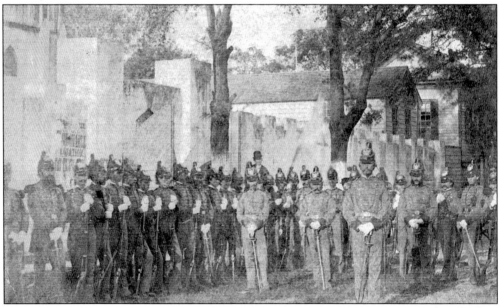

BEAUFORT VOLUNTEER ARTILLERY AND BEAUFORT ARSENAL, C. 1878. Constructed in 1795 on the site of Beaufort's first courthouse, the Beaufort Arsenal was the home of the nation's fifth-oldest military unit. The Beaufort Volunteer Artillery, in full dress uniform, posed for Aiken photographer J.A. Palmer in the post-war photo above. The Arsenal building now houses the Beaufort Museum. (J.A. Palmer.)

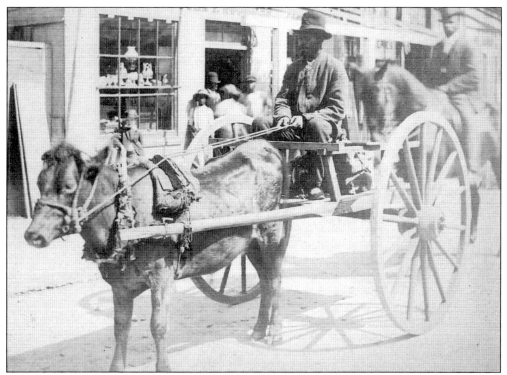

VIEW ON BAY STREET, IN FRONT OF JOHN F. HUCHTING'S STORE, BEAUFORT, C. 1875. On the reverse of this view, which hosts an advertisement for Stuart & Clancey's drugstore in Beaufort, is a somewhat enigmatic title: "A So. Ca. Turnout—Time 2:26." Perhaps it is a tongue-in-cheek reference to the inherent slowness of the mode of transportation pictured.

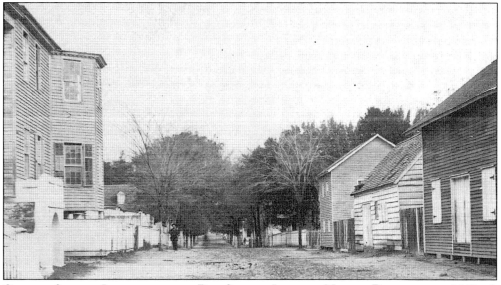

CHARLES STREET, INTERSECTION OF BAY STREET, LOOKING NORTH, BEAUFORT, C. 1863. A portion of the George Parsons Elliott House appears at the far left of this Sam Cooley wartime view. Built in 1844, the building, with alterations, still stands. Most of the other buildings in this view have since been lost. (Sam Cooley, photographer; courtesy of Marvin Housworth.)

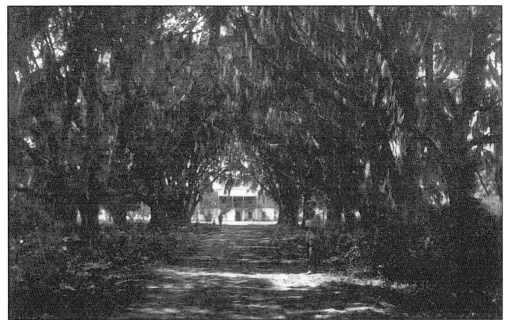

LIVE OAK AVENUE, PLANTATION OF ROBERT B. RHETT, PORT ROYAL ISLAND, C. 1865. Known as "the Father of Secession," Robert B. Rhett, publisher of the *Charleston Mercury*, U.S. senator, and member of the Confederate Congress, lived in Charleston but kept this plantation in Beaufort County. This view is thought to be of the plantation home known as "Woodward." (E. & H.T. Anthony.)

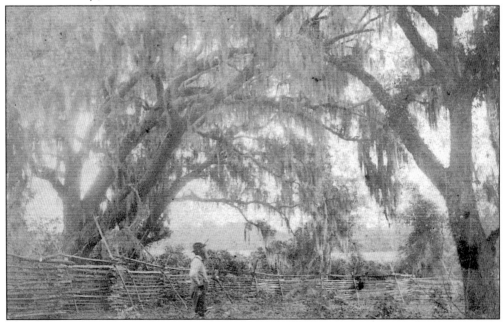

REBEL BARNWELL'S PLACE, C. 1865. Sam Cooley took this photo on another Lowcountry plantation in the Beaufort area. The caption does not give the first name of the owner nor the location of the "Rebel Barnwell's Place," but the photo was most likely taken on Saint Helena Island or Port Royal Island. (Sam Cooley.)

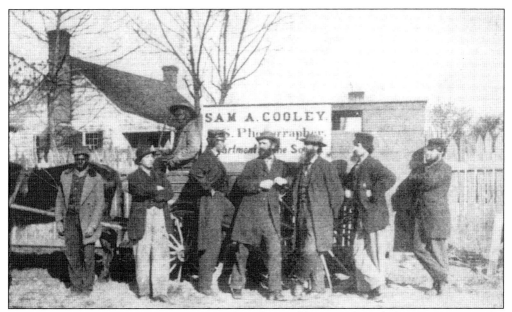

SAM COOLEY, BEAUFORT, C. 1865. Posed in front of his traveling darkroom, Sam Cooley pauses in his duties as U.S. photographer, Tenth Army Corps, Department of the South. As official photographer for the Union forces, it was Cooley's job to document certain aspects of the Union's wartime activities. Cooley, however, also saw that it was to his advantage to make commercially viable photographs such as the one above. Many of the surviving views of wartime Beaufort were captured through his lens. (Sam Cooley.)

FAMILY UNDER PALMETTO TREE, UNKNOWN LOWCOUNTRY LOCATION, C. 1870. A family, dressed in their Sunday finery, rests under a palmetto tree. The serenity and slow-moving pace of this photo reminds the modern viewer that the days were not as hurried 130 years ago. (J.N. Wilson.)

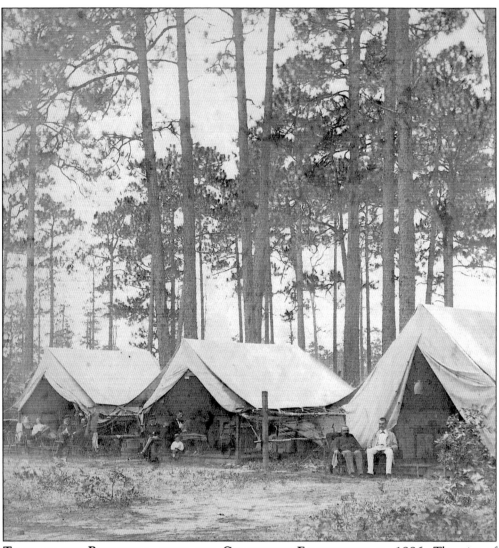

TENTS OF THE BACHELORS, AFTER THE CHARLESTON EARTHQUAKE, C. 1886. The city of Charleston was struck by a violent earthquake on August 31, 1886. Damage was severe and some reports indicated that the death toll reached 92. Thousands of dwellings were damaged; hundreds were virtually destroyed. Brick and masonry dwellings seemed to experience more damage than frame houses. Many of the latter were thrown out of plumb but did not tend to collapse as did the masonry structures. "Earthquake bolts," still visible today in Charleston's historic district, were added to many masonry buildings to guard against future quakes. To escape the aftershocks and mitigate the threat of further injury, many Charlestonians set up tents in open areas of the city. Here is shown the "tents of the bachelors," which were presumedly in an area off by themselves, perhaps outside the city itself. (J.H. Anderson, photographer; courtesy of Marvin Housworth.)

Eight

ON THE PLANTATION

GATE AND LIVE OAKS, THE OAKS PLANTATION, GOOSE CREEK, C. 1895. The Civil War and its aftermath brought myriad changes to plantation life throughout the South, and the once-great rice plantations of the Lowcountry were no exceptions. Gone were the days of unhurried grandeur and unworried splendor, only to be replaced with a daily grind of sweat and hard work. Never again would wealthy landowners order their slaves out into the rice fields. Some of the former slaveowners lucky enough to still have their plantations now found themselves doing much of the planting and harvesting. And, unbeknownst to all, it would not be long before foreign competition and a couple of strong hurricanes would force the working rice plantation into the history books. In this view, two young African-American girls, possibly the children of former slaves, peer through the wrought iron gate of the Oaks Plantation. (Underwood & Underwood.)

OPENING THE FLOODGATES, FLOODING A RICE FIELD AT HIGH TIDE, UNIDENTIFIED RICE PLANTATION, SOUTH CAROLINA, C. 1900. As a crop, rice was very moisture-loving, and the fields needing to be flooded numerous times during the growing season. The ready availability of large amounts of freshwater and a suitable topography made the South Carolina Lowcountry an ideal spot for planting rice. (Keystone View Company.)

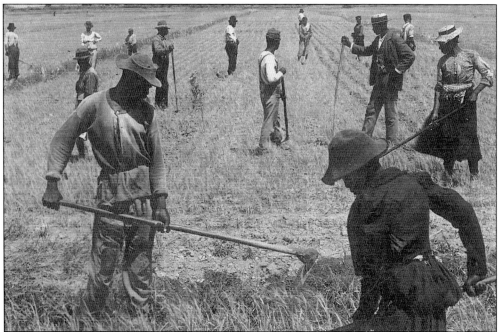

HOEING RICE, UNIDENTIFIED RICE PLANTATION, SOUTH CAROLINA, C. 1900. Rice was also a high-maintenance crop that required much labor to keep weeds and wild strains from ruining the harvest. Here, plantation workers use hoes to weed out unwanted plants. Note the overseer at the upper right. (Keystone View Company.)

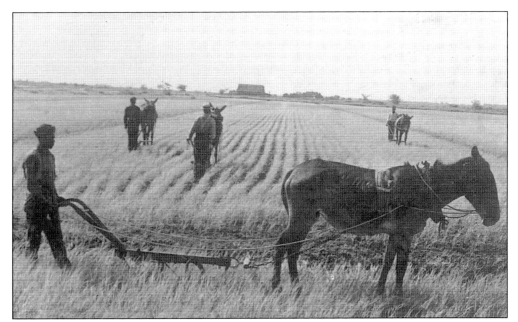

CULTIVATING RICE, UNIDENTIFIED RICE PLANTATION, SOUTH CAROLINA, C. 1910. As labor became more expensive, new ways of cultivating rice were utilized. This photo demonstrates how horses were used to keep the rows weeded, freeing plantation hands for other chores. (Keystone View Company.)

RICE FIELD, UNIDENTIFIED RICE PLANTATION, SOUTH CAROLINA, C. 1875. A rice plantation required a complex system of irrigation and drainage canals so that the fields could be flooded and drained as necessary. The view above shows the canals and ditches used for this purpose. (J.A. Palmer.)

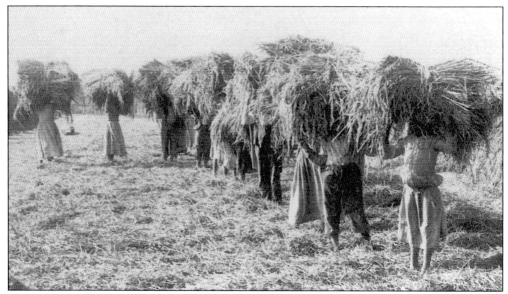

PLANTATION WORKERS CARRYING RICE, UNIDENTIFIED RICE PLANTATION, SOUTH CAROLINA, c. 1890. When the rice was harvested, it was brought to a central location to be threshed. This process removed the coarse grain, which was then sent to the mill. Here are shown plantation hands carrying the freshly harvested sheaves to be threshed. (Underwood & Underwood, publishers; courtesy of Joseph Matheson.)

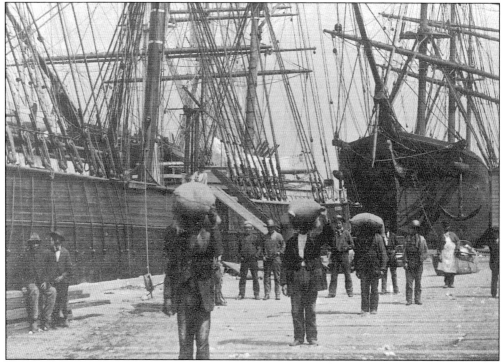

TOTING RICE, CHARLESTON WHARVES, c. 1880. After the rice was milled, it was placed in sacks to be shipped. Shown in this photo are dock hands transporting sacks of rice to the waiting ships. (Kilburn Brothers, publishers; courtesy of Len Ances.)

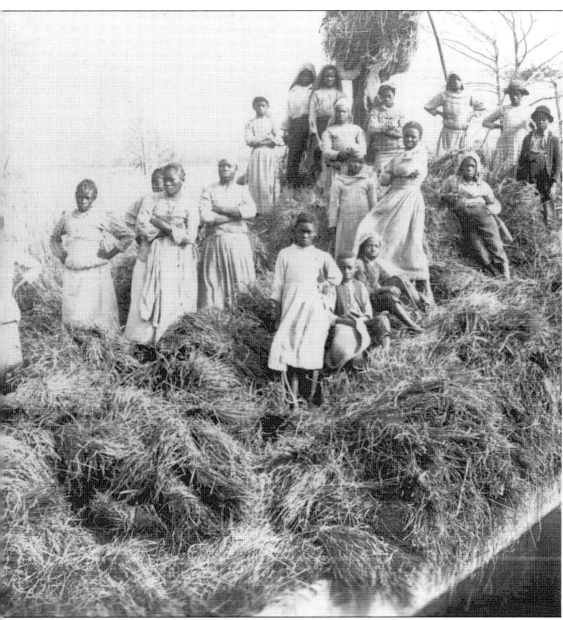

RICE RAFT WITH PLANTATION HANDS, NEAR GEORGETOWN, C. 1890. After the rice was harvested and threshed, the grain was sent to the mill to have the hulls removed. The straw that remained could be used for fodder, bedding, or even paper stock. In this interesting stereoview, plantation hands pose on a barge filled with such rice straw. This barge was probably bound for sale at Georgetown. As the nineteenth century came to a close, the viability of the Lowcountry rice plantation was in jeopardy. Rice prices were declining, primarily due to increased production in other parts of the world, Asia in particular. Also, a series of powerful hurricanes hit the South Carolina coast, virtually destroying the complex system of dikes and ditches needed for irrigation of the crop. (Underwood & Underwood.)

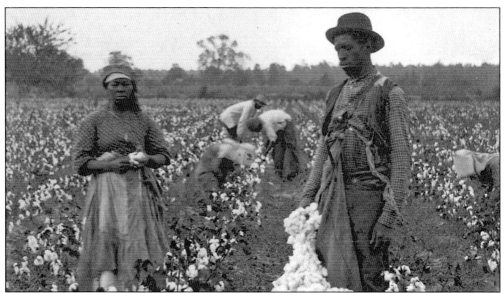

COTTON FIELD, UNIDENTIFIED COTTON PLANTATION, SOUTH CAROLINA, C. 1875. Cotton was a somewhat more viable crop than rice in the late 1800s and early 1900s. Large amounts were needed by the burgeoning textile industry and Southern plantations supplied that need. Here, two field hands show off their morning's work. (J.A. Palmer.)

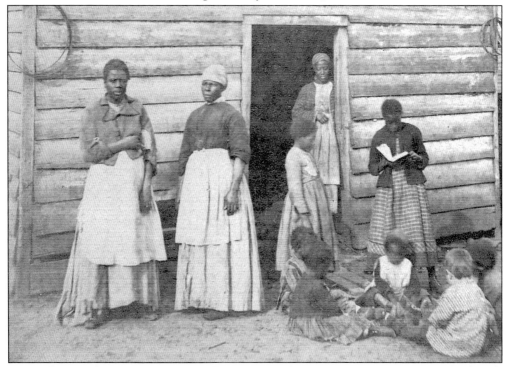

"AUNT BETSY'S CABIN," UNIDENTIFIED PLANTATION, SOUTH CAROLINA, C. 1875. Even though slavery had been abolished, the old ways died hard. African Americans still lived in sub-standard conditions on the farms and plantations of the South. This one-room cabin was probably better than most. (J.A. Palmer.)

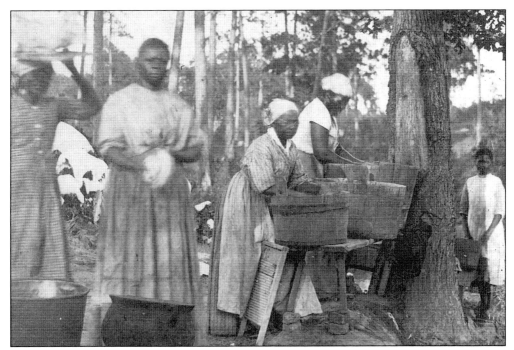

WASHERWOMEN, UNIDENTIFIED PLANTATION, SOUTH CAROLINA, C. 1875. And the chores still needed to be done. The lack of modern conveniences such as washing machines and dryers made the simplest of chores time-consuming and exhausting. Washday on the plantation was a daylong ordeal. (J.A. Palmer.)

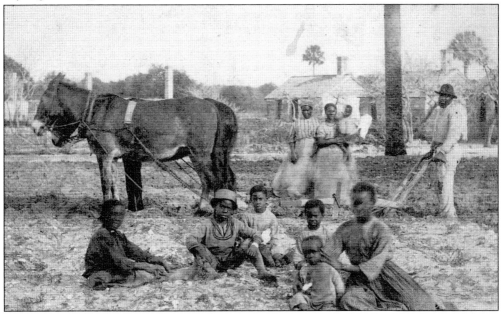

FARMING, UNIDENTIFIED PLANTATION, C. 1875. Life continued to be hard for the freed slaves still living on the plantation. Most lived hand-to-mouth. And even those African Americans who were fortunate enough to own their own farms found things just as difficult, if not more so. (New Series; courtesy of Joseph Matheson.)

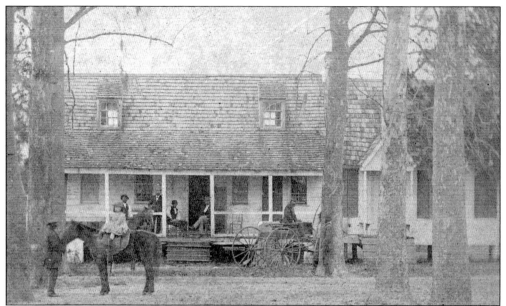

VIEW OF THE OLD HOMESTEAD, WHEELOCK'S PLANTATION, MOUNT PLEASANT, C. 1870. W.R. Wheelock and his family are posed in front of their home in this George Barnard stereoview. Life on Wheelock's plantation had changed much in the past 25 years, and would change even more drastically in the future. (George N. Barnard.)

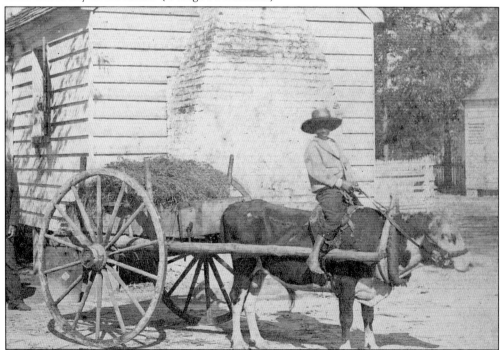

BULL CART GOING TO MARKET, UNIDENTIFIED PLANTATION, SOUTH CAROLINA, C. 1870. In this charming view of plantation life, a young African American steers his bull cart to the market. Many photographers offered for sale whimsical views such as these, their availability today testifying to their popularity then. (George N. Barnard.)

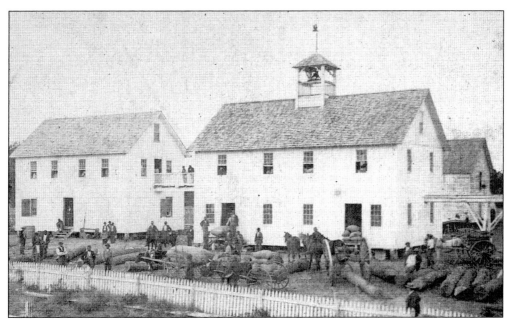

STORE AND GINNING MILLS, ALEX. KNOX'S PLANTATION, MOUNT PLEASANT, C. 1875. Photographer George Barnard took a series of stereoviews on Alex Knox's plantation in Mount Pleasant. Here appears the store and cotton gin. Also in the view are some rather large logs awaiting their turn at the sawmill. (George N. Barnard.)

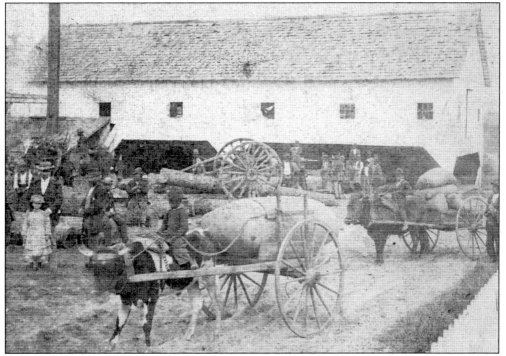

SAWMILL AND BOX FACTORY, ALEX KNOX'S PLANTATION, MOUNT PLEASANT, C. 1875. In another Barnard view, Knox's sawmill and box factory are featured. Note the large-wheeled cart in the background that was used to transport the huge logs into the mill. (George N. Barnard.)

117

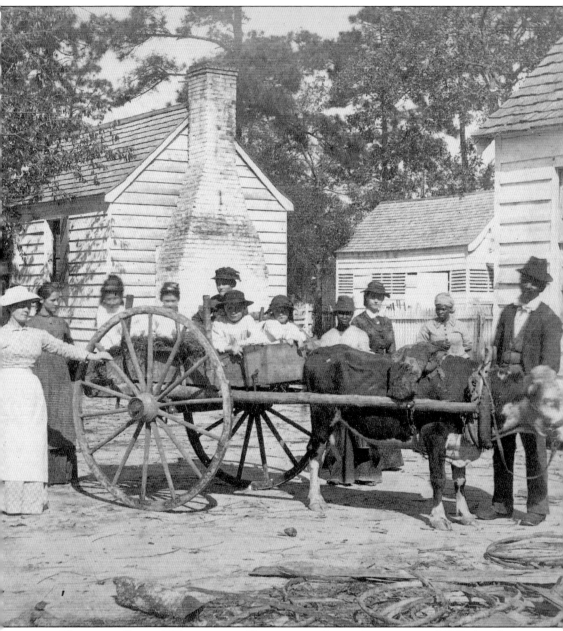

"Suburban Group," Unidentified Plantation, South Carolina, c. 1875. Another quaint view of life on the plantation, this photo has been posed to give the impression of a family all dressed up for an outing into town. This view was probably taken by George N. Barnard (check out the resemblance to the building and cart in the view on page 116), although it was published by his successor in business, F.A. Nowell. Both Barnard and Nowell catered to the tourists who frequented the gallery located at 263 King Street in Charleston. Judging by the prevalence of their views still in existence over 100 years later, they must have sold thousands of views in their time. (F.A. Nowell.)

118

Nine

TEDDY ROOSEVELT'S DAY
AT THE FAIR

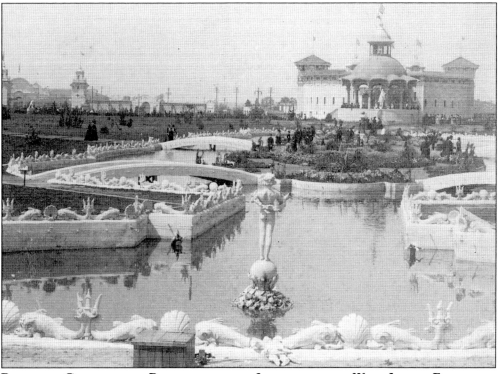

BEAUTIFUL GROUNDS AND BUILDINGS OF THE INTERSTATE AND WEST INDIAN EXPOSITION, CHARLESTON, 1902. Not many South Carolinians know that their native state has played host to a world's fair. During the six months that the South Carolina Interstate and West Indian Exposition was open (December 1901–May 1902), a total of 675,000 people attended. The ostensible purpose of the fair was to showcase South Carolina's commercial advantages in order that more trade and investment could be attracted to the state. Many magnificent, but temporary, buildings were erected on the grounds of old Washington Race Course to house exhibits prepared by numerous states and foreign countries. Everything was painted an off-white color and the fairgrounds were nicknamed "The Ivory City." Shown above are the famous "Sunken Gardens" and the bandstand, behind which rises the Exposition Auditorium. The bandstand was the only structure built for the Exposition to survive. Moved and heavily renovated, the structure presently graces Hampton Park. (Underwood & Underwood.)

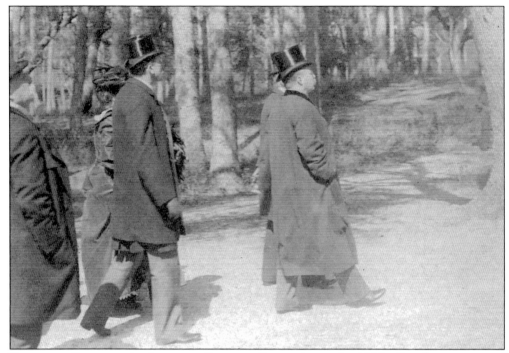

PRESIDENT ROOSEVELT'S ARRIVAL, CHICORA PARK, APRIL 8, 1902. On the morning of April 8, U.S. President Theodore Roosevelt arrived by train to visit Charleston and attend the exposition. He disembarked at the train station and walked through Chicora Park to the Navy Yard, which he toured. (Underwood & Underwood.)

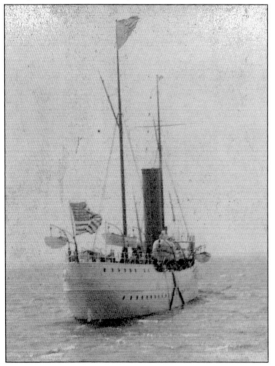

REVENUE CUTTER ALGONQUIN FLYING THE PRESIDENT'S FLAG, CHARLESTON HARBOR, APRIL 1902. The *Algonquin* had been tied up at Chicora Wharf awaiting the President's arrival. After touring the Navy Yard, the Roosevelts and the remainder of their party boarded the waiting ship for a tour of Charleston Harbor. (Underwood & Underwood.)

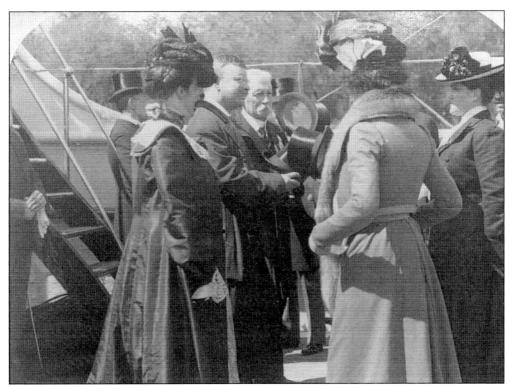

PRESIDENT AND MRS. ROOSEVELT RECEIVING GUESTS ON BOARD THE ALGONQUIN, CHARLESTON, APRIL 8, 1902. Once on the *Algonquin*, the President and the First Lady greeted the many new acquaintances who were to accompany them on the sightseeing tour of the harbor. (Underwood & Underwood.)

PRESIDENT ROOSEVELT ACKNOWLEDGING THE SALUTE OF WARSHIPS ON THE ALGONQUIN, CHARLESTON HARBOR, APRIL 8, 1902. As the *Algonquin* proceeded down the Cooper River, the warships *Topeka*, *Cincinnati*, and *Lancaster* greeted the President with a salute or their guns. Here, he doffs his hat to the nation's fighting men. (Underwood & Underwood.)

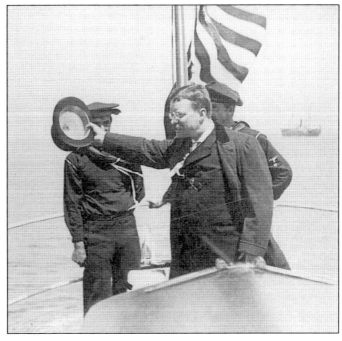

THE NATION'S PRESIDENT VIEWING THE FAMOUS HISTORIC SITES, FROM THE *ALGONQUIN*, CHARLESTON HARBOR, APRIL 8, 1902. The *Algonquin* proceeded past Castle Pinckney and steamed toward Forts Moultrie and Sumter. In this view, the president looks toward the bastions which he knew to have played such a large role in the nation's history. (Underwood & Underwood.)

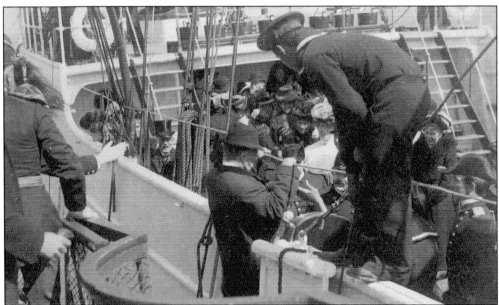

OUR AGILE PRESIDENT CROSSING FROM TUG TO *ALGONQUIN* IN HEAVY SEA OFF FORT SUMTER, CHARLESTON HARBOR, APRIL 8, 1902. Always a man to hearken to the soldier's call, President Roosevelt did not miss the chance to walk the ramparts of Fort Sumter. Knowing its history and what it stood for to his countrymen—both Northerner and Southerner—the president had to experience firsthand the ambience of the fort. In this photo, he crosses back to the *Algonquin* from the *Governor Howe*, the tugboat which had carried him to the fort and back. (Underwood & Underwood.)

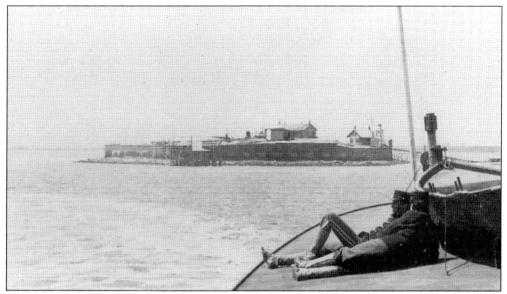

VIEW OF FORT SUMTER, CHARLESTON HARBOR, C. 1900. This is a view of what Fort Sumter looked like when the president visited. Outbuildings and a wooden wharf had been added since the end of the Civil War, along with a familiar sight—two large rifled cannon that had been placed at Sumter during the Spanish-American War. The soldiers at the fort fired both guns for President Roosevelt during his short visit. (Underwood & Underwood.)

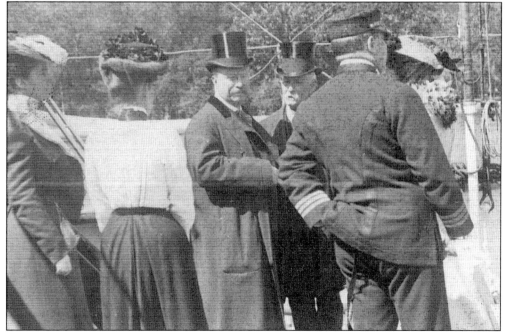

PRESIDENT ROOSEVELT, MAYOR SMYTH, AND INVITED GUESTS ON THE ALGONQUIN, CHARLESTON, APRIL 8, 1902. Back on board the *Algonquin*, the president was able to spend more time with those accompanying him. Guests on board included Charleston Mayor J. Adger Smyth, Captain F.W. Wagener, Attorney General Knox, and Secretaries Wilson and Cortelyou of Roosevelt's cabinet. (Underwood & Underwood.)

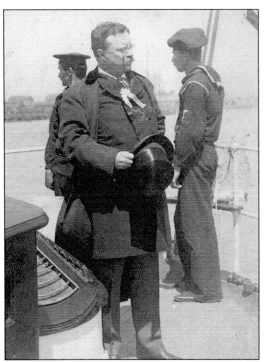

THE NATION'S CHIEF VISITING THE EXPOSITION, CHARLESTON HARBOR, APRIL 8, 1902. The *Algonquin* completed the tour of the harbor and tied up at Boyce's Wharf. Here it seems that the president may have paused to reflect on the historic importance of the harbor's sights. After his moment of reflection, the he continued on into the city, attending a banquet at the Charleston Hotel and spending the night at the Saint John Hotel. (Underwood & Underwood.)

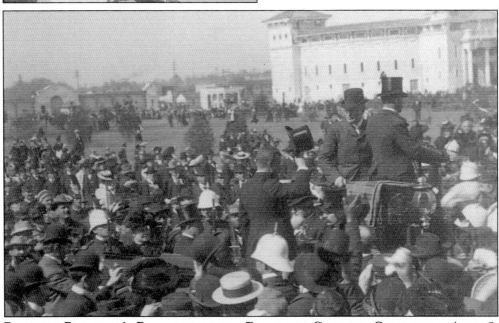

PRESIDENT ROOSEVELT'S RECEPTION ON THE EXPOSITION GROUNDS, CHARLESTON, APRIL 9, 1902. The next morning, an enthusiastic crowd of 24,000 awaited the president as he entered the "Ivory City" at the head of a long military parade. April 9 had been declared "President's Day" at the Exposition, and his lengthy itinerary included the review of the troops in the parade, a speech at the Exposition Auditorium (the large building in the background in the above photo), a luncheon at the Women's Building, and a stroll through the various buildings and exhibits. (Underwood & Underwood.)

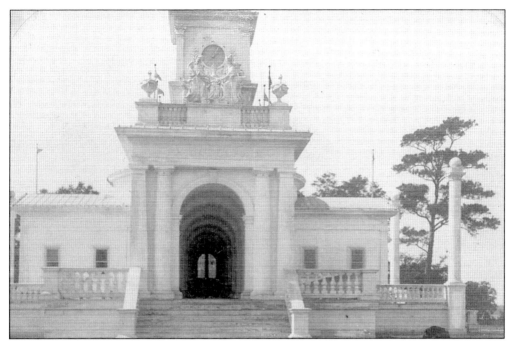

THE PHILADELPHIA BUILDING, CHARLESTON EXPOSITION, 1902. The City of Philadelphia was one of the exhibitors which constructed a building at the Exposition. On January 9, 1902, the Liberty Bell arrived in Charleston and was put on display inside the Philadelphia Building. (Griffith & Griffith.)

LIBERTY BELL, INDEPENDENCE HALL, PHILADELPHIA, PENNSYLVANIA, C. 1910. Although this stereoview was not taken at Charleston, it does capture the magnificence of our national icon of freedom. The Liberty Bell remained on exhibition at the fair until closing. (Keystone View Company.)

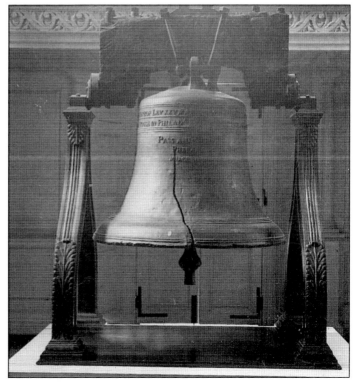

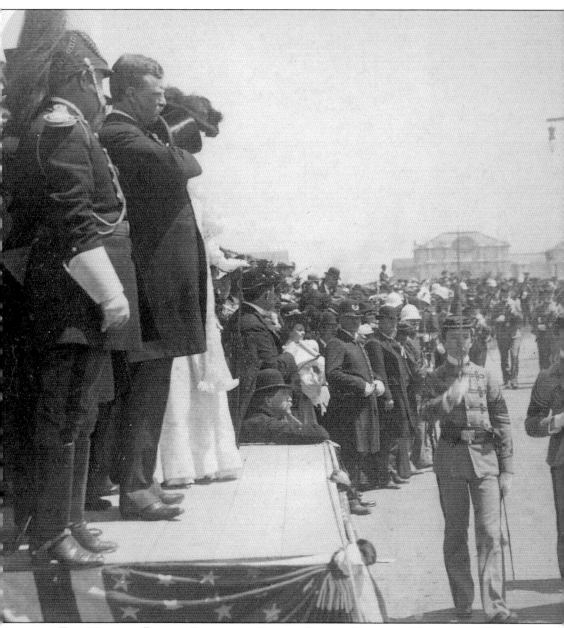

THE MILITARY PARADE PASSING IN REVIEW BEFORE PRESIDENT ROOSEVELT, CHARLESTON EXPOSITION, APRIL 9, 1902. The City of Charleston naturally pulled out all the stops for the visiting president. A large parade was held, over which presided the beloved commander-in-chief. Here the president acknowledges the colors presented by the troops. Participants in the parade included the Band of the U.S. Corps of Artillery, Companies C and M of the U.S. Corps of Artillery, the Charleston Light Dragoons, cadets from the Citadel and the Virginia Polytechnic Institute, militia units from Virginia, North Carolina, and Florida, and Marines and Jackies from the *Cincinnati, Lancaster, Topeka, Forward, Hamilton,* and *Algonquin.* (Underwood & Underwood.)

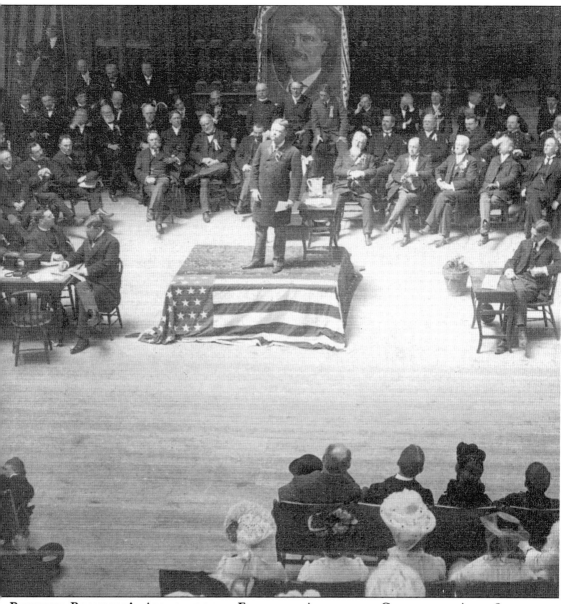

PRESIDENT ROOSEVELT'S ADDRESS IN THE EXPOSITION AUDITORIUM, CHARLESTON, APRIL 9, 1902. "To North and South, the Great War's memories are priceless heritages of honor," remarked the president in his speech at the Exposition. A rapt crowd of hundreds was in attendance to hear Roosevelt's words of wisdom. The president had just visited Fort Sumter and addressed some of his words to the subject of the Civil War. "All of us can glory alike in the valor of the men who wore the grey. Those were iron times, and only iron men could fight to its terrible finish the giant struggle between the hosts of Grant and Lee." Also giving speeches that day were Governor McSweeney of South Carolina, Governor Aycock of North Carolina, Mayor J. Adger Smyth, and Captain F.W. Wagener, who was the driving force behind the Exposition. The president also presented a special sword to Major Micah Jenkins of South Carolina in recognition of his services with the Rough Riders during the Spanish-American War. (Underwood & Underwood.)

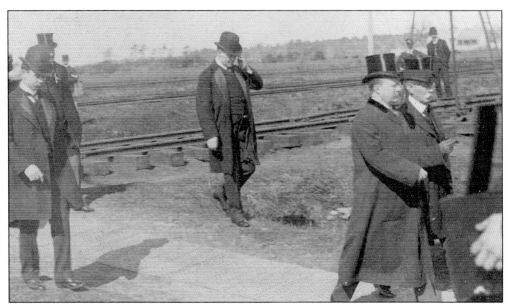

PRESIDENT ROOSEVELT AND MAYOR SMYTH ARRIVING AT SUMMERVILLE, APRIL 9, 1902. After leaving the Exposition, President Roosevelt and his party traveled by special train to Summerville, where an elegant banquet awaited them. He and Mrs. Roosevelt spent the night at the Pine Forest Inn as the guests of Captain F.W. Wagener. Shown here are the president and Mayor Smyth walking down the red carpet just after their arrival. (Underwood & Underwood.)

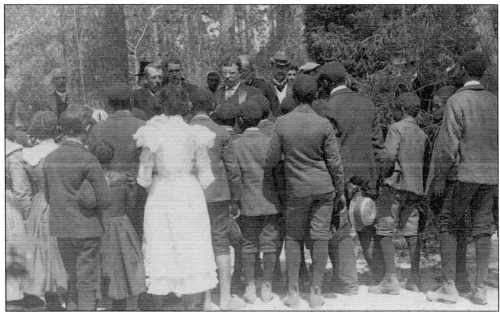

AFRICAN-AMERICAN TEA PICKERS GREET PRESIDENT ROOSEVELT, PINEHURST TEA FARM, SUMMERVILLE, APRIL 10, 1902. On the morning of April 10, the president visited the Pinehurst Tea Farm, and later reboarded the train for the trip back to Washington. In this photo, a group of African-American youths crowd around President Roosevelt to present him with a special gift of song. (Underwood & Underwood.)